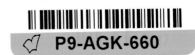

THE
PORTRAIT
IN CLAY

THE PORTRAIT IN CLAY

PETER RUBINO

Watson-Guptill Publications/New York

Acknowledgments

I want to thank my family, friends, students, and all the professionals who helped me transform 25 years of discussion into this 160-page book.

First and foremost, to my wife for supporting this endeavor and allowing me the time and space required for its completion. Her intuitive comments raised me to a higher level of authorship.

To my son Dean for making this a truly unique book by sitting patiently while modeling during tedious photo sessions and offering insightful editing suggestions.

To my son Lukas who coordinated, corrected, and prepared the manuscript in disk form for presentation at the eleventh hour.

To my son Jesse for hollowing the scuptured head perfectly in preparation for firing and also for introducing me to the computer.

To my mother for always being supportive of my artistic pursuits.

To my father, the artist who mentored me in my early years of creative expression and who introduced me to the discipline of sculpture. He continues to be an inspiration.

To the students who attend my classes and workshops for challenging me to realize that there is always more to learn.

To Dominic Ranieri, patina expert, master mold maker, and caster, for 25 years of friendship, support, and guidance, and for teaching me the value of quality workmanship. "No cheating on the family recipe."

Thanks also to the following:

Debranne Cingari, photographer, Fairfield, CT
Jack Rudolf, Connecticut state senator
Peter Leggieri, Peters Sculpture Supply, New York, NY
Dale Shaw, The Clay Place, Norwalk, CT
Bill and Nora Hindle, Photo Network, Wilton, CT
Barney Hodes, sculptor and instructor
David Dewey, painter and author

Senior Editor: Candace Raney
Project Editor: Alisa Palazzo
Designer: Jay Anning
Production Manager: Ellen Greene

Copyright © 1997 Peter Rubino
All photography by Debranne Cingari

First published in 1997 in the United States by Watson-Guptill Publications, Crown Publishing Group, a division of Random House Inc., New York
www.wgpub.com
www.crownpublishing.com

Library of Congress Cataloging-in-Publication Data
Rubino, Peter.
 The portrait in clay / Peter Rubino.
 p. cm.
 Includes index.
 ISBN 0–8230–4102–6
 1. Portrait sculpture—Technique. I. Title.
NB1293.R83 1997
731'.82—dc21 97–17653
 CIP

Printed in the United States of America
First printing, 1997

8 9 10 / 15 14

In memory of my teacher, Gaetano Cecere,
for teaching me to see

and

To Maestro Raphael Ranieri, a true Renaissance man
His spirit and knowledge are left behind
To sip and savor like his homemade wine

CONTENTS

INTRODUCTION

When I first began my studies in sculpture in art schools and studio settings, I was frustrated, amazed, and disappointed that there were no books that thoroughly described how to sculpt the portrait in clay.

Living and studying in New York City exposed me to great works of art as I visited the many museums, galleries, and sculptors' studios. This exposure broadened my vision of sculpture but didn't provide a step-by-step approach for me to follow. Today, 25 years later, I find that there is still a need for a book that stresses solid fundamentals and provides a comprehensive, detailed, how-to, easy-to-follow system for sculpting a portrait in clay.

This book does exactly that and more. Using my proven methods and simplified approach, novice, intermediate, and advanced students will all be able to consistently create—with confidence and joy—quality portrait sculptures. *The Portrait in Clay* is a complete sculpture reference that can supplement studio class instruction or be used by itself, especially when classes are not available to students.

I'm deeply committed and passionate about sculpture. It's the one art form that truly allows me to express my creative energy. There's always something new to discover! I enjoy exploring the fascinating worlds of portrait, figure, and abstract sculpture; each has its own unique form, yet in a way, they share a common aesthetic. I hope that the information in this book helps make your experience with portrait sculpture a rewarding, fulfilling, and successful one.

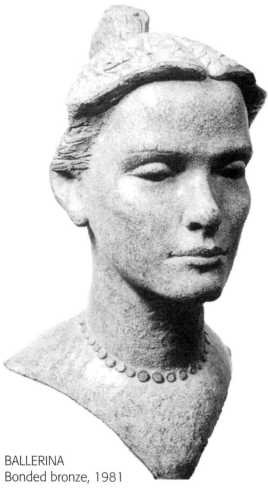

BALLERINA
Bonded bronze, 1981

Sculpted from the live model. Bonded bronze is a casting composition of bronze and resin. All the bronze and bonded bronze sculptures on these pages were cast by Dominic Ranieri of Ranieri Sculpture Casting (see Resources).

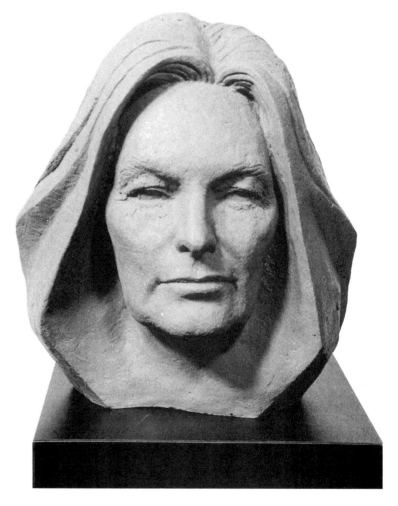

GHISLAINE
Terra-cotta, 1995
Sculpted from the live model.

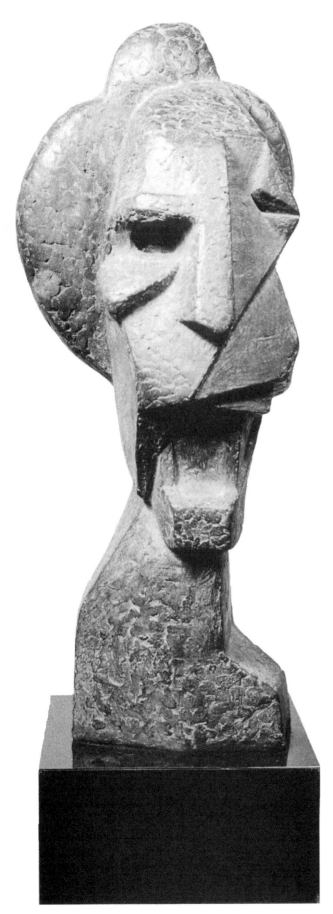

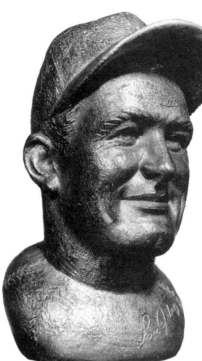

LOU GEHRIG
Bronze, 1990

Sculpted from photographs.

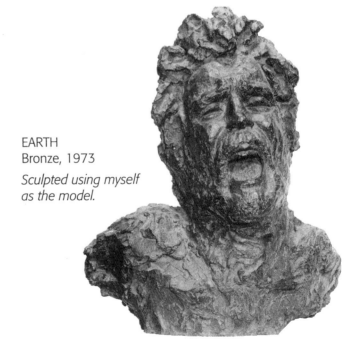

EARTH
Bronze, 1973

Sculpted using myself as the model.

NUCLEAR WARHEAD
Bonded bronze, 1975

Sculpted from imagination, without any preconceived ideas or preliminary studies made prior to sculpting.

THE BASICS

Before starting to sculpt a portrait, it's important to take a look at the elements of the human head and analyze their various planes. By comparing a model of a human skull to French artist Jean-Antoine Houdon's anatomical head sculpture, as we'll do in this section, you'll learn the basic anatomy, proportions, and symmetry of the human head. Then, through a step-by-step demonstration of the construction and development of the planes of the head, you'll learn all the artistic fundamentals and the sculptural language that you'll need to sculpt a clay portrait from a live model.

THE SKULL

The plane structure and geometric foundation of the human head, which you need to create a portrait in clay, are based on the angles, contours, surface directions, shapes, and proportional relationships of the anatomy and the bony landmarks of the underlying skull. To be truly successful at portrait sculpture, you need a good foundation—good observation skills and a good understanding of the skull and its anatomy.

The skull is a singular, symmetrical mass, with proportions that remain constant from one skull to another. The features on this solid architectural form are arranged in a unique geometric system; this is the facial armature that supports the head. It's a good idea to have a model human skull on hand to further your studies, and you can find plastic models at local hobby and art supply stores. (See Resources.)

The following photographs show the casting of the magnificent anatomical head of a sculpture by French artist Jean-Antoine Houdon (1741–1828) that has served as a reference for serious art students for hundreds of years. Created in 1767, this rare antique casting of the head resides in the sculpture studio at the National Academy School of Fine Arts in New York City, where I currently teach. (There is also one casting at the Pennsylvania Academy of Art and another at the Royal Academy in London.)

Having this Houdon casting on site is like having the master himself in the studio. By examining the piece, you can learn many important things about the anatomy of the human skull. Observe the sculpture closely, and compare it with the model skull; in each case, I've indicated the areas to which you should pay special attention with dashes.

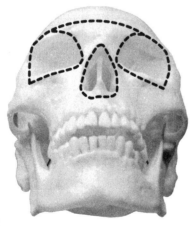

The square eye sockets, with rounded corners, slant back from the nose to the sides of face. The eyeballs fit deeply into the sockets and slant to the sides in the same direction. The end of the nasal bone (the opening for the nose that we see on the skull) is shaped like a triangle, as is the tip of nose.

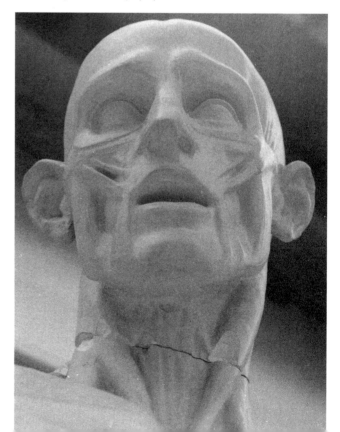

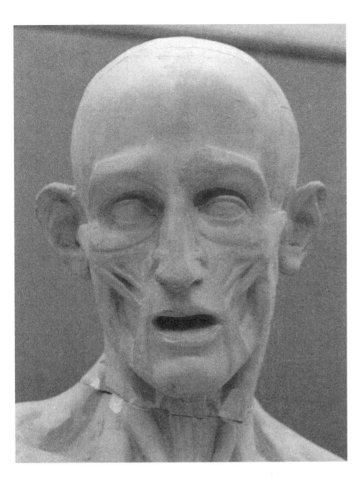

The skull is widest at the cheekbones across the front of the face. The contour of the cheekbones flows into the upper jawbone, under the base of the nasal bone, from side to side. This contour changes direction at the side of the head at which point it flows up along the side of the eye socket, around the brow bone, across the forehead, and down the side of the other eye socket completing an oval shape. The corners of the mouth and the width of the chin line up with the center of the eyes. Also compare the skull's forehead, angle of the cheekbones to chin, and circular section of the mouth, all highlighted here, to Houdon's sculpture.

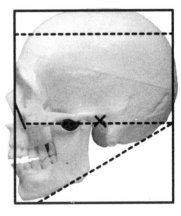

The height of the skull from the bottom of the chin to the top of the forehead is the same as its depth from the brow to the back of the skull. The hole of the ear canal (marked with an x) falls in the center of the side of the skull. The jawbone, in front of the ear canal, drops straight down, then changes direction and slants to the chin. The angle of the cheekbone near the front of the face slants down and back. It meets the zygomatic arch, which travels from the cheekbone back to the ear canal. The cylindrical sternocleidomastoid muscle, on the side of the neck, runs from behind the ear down the neck to the clavicle (collarbone) in front.

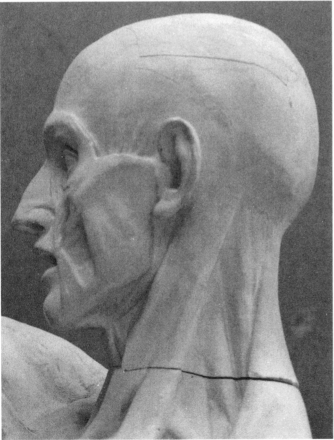

The mouth and chin form a cylinder shape. At this angle you can also see the convex curve of the front of the brow bone.

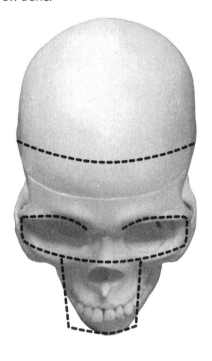

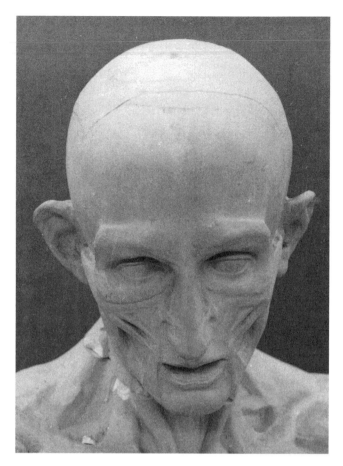

The back of skull is widest at the sides above the ears. The top of the head rises to a gentle point from the sides, and the bottom of the skull, behind the ears, angles inward to the center of the neck. The base of the ball of the skull starts out level with the ear canal and curves gently downward across the back of the head. The trapezius muscles are the large muscles of the back of the neck and shoulders.

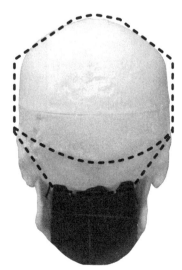

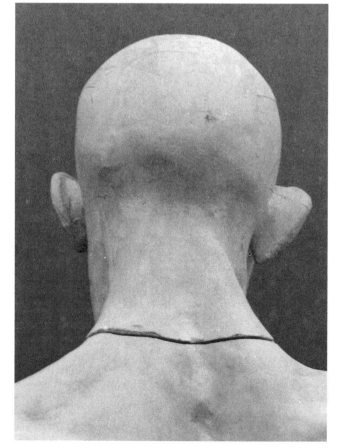

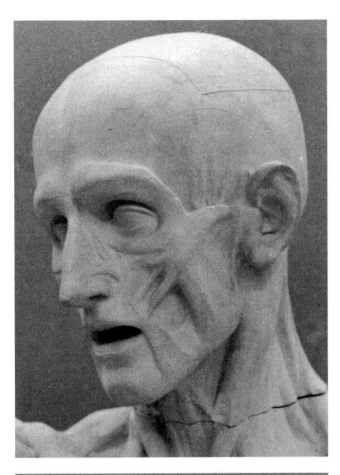

The malar bone (circled here) has a surface both in its front and side. The outside corner of the eye socket, which is connected to the malar, has a broad opening from top to bottom.

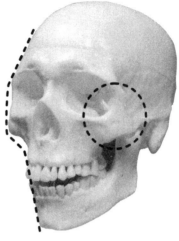

Although you cannot see this angle on Houdon's casting, the jawbone, from the bottom view, swells out a bit along its outer edge about halfway between the back of the jaw and the chin. (This point is marked with the horizontal line.)

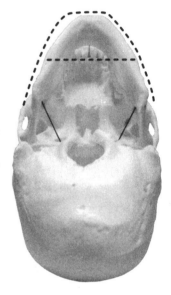

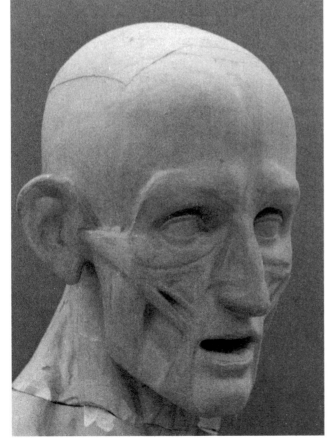

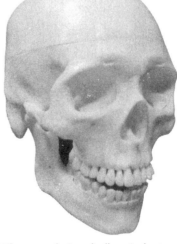

The temple is a hollow indent located behind the eye socket above the zygomatic arch. Note also that the triangular Adam's apple sits in between the sternocleidomastoid muscles on each side of the neck.

THE PLANES OF THE HEAD

It's crucial for your growth as a sculptor to understand the proportions, position, and planes of the human head—the three P's—before beginning a portrait sculpture. The planes, or surfaces, of the form help you locate strategic landmarks, indicate the direction and changing directions of the subject, and aid in the representation of shape and volume. The character and likeness of your subject originates in the proportions and shape of the head and features. Learning the basic plane structure assures the solid foundation you'll need to develop a convincing and accurate three-dimensional portrait.

When sculpting, keep in mind the following important proportions, as mentioned in the previous section: the height from the bottom of the chin to the forehead is the same as the depth from the forehead to the back of the skull. In addition to this, the width of the face, from cheekbone to cheekbone, is considerably smaller than the height or depth. Note that the average adult head is approximately 7½ inches high by 7½ inches deep by 4½ inches wide, and keep these dimensions in mind when developing the head mass.

Planes are really the road map of a form, helping to establish landmarks, such as the cheekbones, jawbone, forehead, nose, chin, and eye sockets. Once you learn the basic planes, you can start to identify the more subtle ones. Overall, the human head is a very organized mass with the features located in very specific places. The eyes, nose, mouth, and chin are located on the front of the head, which is called the *face plane*. The ears and jaw fall on the *side plane* and the hair is on the *top, back,* and *side planes.*

Learning the plane structure of the head is paramount to creating a truly sculptural form. Sculptural forms have volume. An easy way to understand volume is to think of and begin with geometric shapes. Geometric shapes have volume, and that's why, as you'll see in the photographs below and in subsequent sections, I begin building up my portrait with a cylindrical shape for the neck and a rectangular one for the head. (See photos opposite.)

The forms of the face are extremely elusive, flowing rhythmically across the surface—from high to low points, from top to bottom, from side to side, and from front to back. One way sculptors can capture these forms is to use planes and geometric shapes to transform complicated human anatomy into simple sculptural language. The planes give us the direction and surface of the form while the geometric shapes help us see rhythms and patterns.

In this section, I'll take you through the basic steps of constructing a portrait in clay, in order to analyze the main planes of the human head. Read through this, and in the next section (on page 44) you'll actually create a head yourself. After reading this, you may also want to practice sculpting the planes first, before working from a live model.

When looking at my piece here, you may notice some small planes (at the tip of the nose, for example) and details of individual features that I don't describe here. I will, however, explain the development of these more subtle planes and details in *Part III: The Features in Detail* later on. Likewise, I'll discuss all the necessary tools and equipment at the start of *Part II: The Sculpting Process* before you actually begin.

After observing and sculpting a number of heads you may decide to simplify or modify the plane structure shown here, and I encourage you to discover new planes; don't hesitate to incorporate them into your work when creating the geometric foundation of the human head. Also note, when developing the planes of the head, that it's important to keep the form symmetrical as you sculpt, allowing the piece to evolve slowly without finishing any one part before another. Adding and subtracting pieces of clay with both hand and tool is the basic process of clay modeling. Therefore, you can expect to make many adjustments (not mistakes) to the form while you're working.

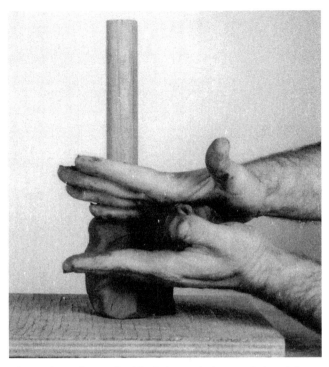

I begin by rolling cylindrical shaped pieces of clay (also called coils) *using the palms of my hands.*

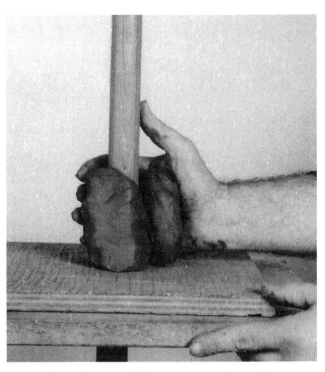

I press the coils around the armature pole gently, one at a time, to create the cylinder shape of the neck. Note that I don't flatten the coils against the armature. (See page 44 for information on armatures and other equipment.)

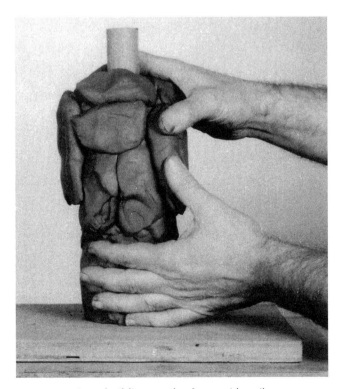

Next, I continue building up the form with coils to develop the basic block shape of the head mass. To create the front sides and back of the head, I place some clay pieces vertically.

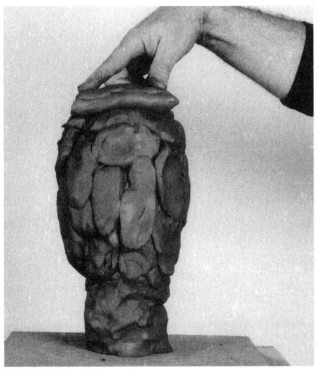

I also place clay horizontally across the top of the head mass.

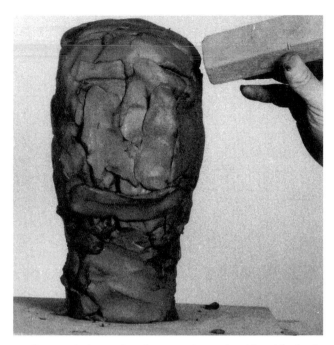

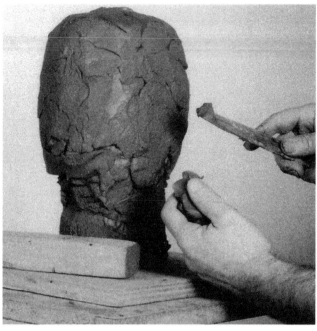

To firm and shape the clay I tap it gently with a block of wood, being sure to tap all around the head mass to make it rectangular in shape. (See page 45 for information on tools.)

I also begin filling in spaces between the coils with small pieces of clay. To do this, I hold some fresh clay in one hand and dip into it with the wood modeling tool, taking up small pieces of clay and placing them wherever there are holes or spaces.

At this stage, I decide where the chin should be, and using the wood modeling tool, cut a horizontal line in the clay at that spot parallel to the top of the head. I cut back in toward the neck about 1 inch with the long edge of the modeling tool, then cut down the neck to the base, and remove the excess clay to form the plane under the jaw and chin. At this stage, the neck should remain as wide as the head mass is at the sides; I'll narrow the neck later on.

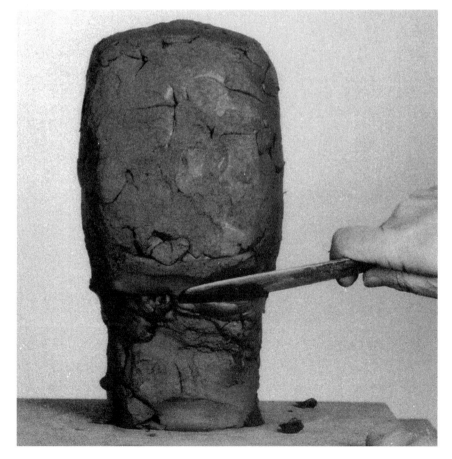

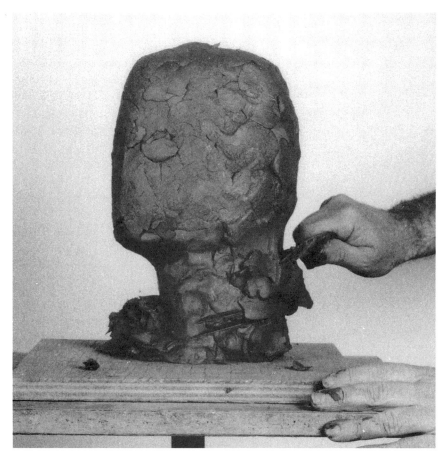

Still using the wood modeling tool, I cut some clay away at the back of the neck to distinguish the neck from the head. At this point, it's a good idea to check the proportions of the head—that the height from the bottom of the chin to the forehead is the same as the depth from the forehead to the back of the skull. I also make sure all opposite sides are parallel to one another, and tap down all lumps and bumps with the wood block (as in the top left photo on the previous page). I'm now ready to position features.

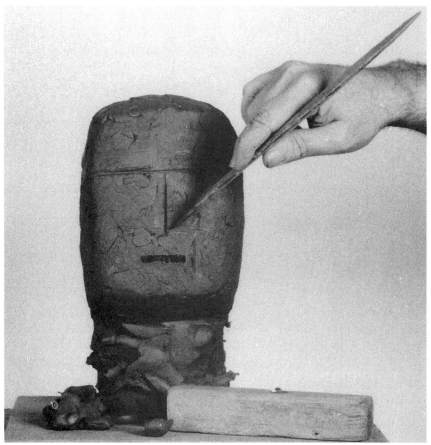

The front of the head is called the front plane *or* face plane *and is divided into thirds from top to bottom. I draw a line across this plane one third of the way down from, and parallel to, the top. This is the brow line. To indicate the nose position, I draw a vertical line in the center of the head, extending from the brow line down to the end of the middle third of the face plane, and draw a v shape at the end of it. A small horizontal line, drawn parallel to the brow line and in the middle of the lower third of the face plane, indicates the mouth placement.*

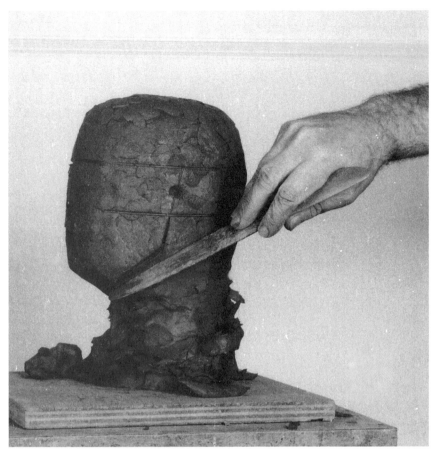

The sides of the head are called, logically, the side planes. Each ear canal is located at the center of each side plane. To find this spot, I extend the brow line and the line at the bottom of the nose across both side planes from front to back, making sure to keep the lines parallel to the top of the head. On each side plane, I poke a hole, or draw an x, in the clay (using the handle end of a wood tool), dead center between the extended lines, to indicate the location of the ear canal. The next step is to draw a line, about 1 inch in length, straight down from the lower line on each side plane, just under the ear canal; then I change direction and continue this line toward the chin. This is the jaw line. I carve some clay from under the jaw to bring out its structure from the side of the neck.

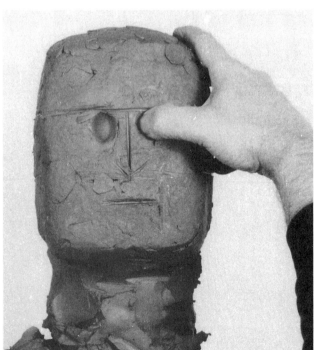

To create the eye sockets on the face plane, I place my thumbs in the center of the head 1 inch apart just under the brow line. (For more detailed instructions on constructing the eyes and other features see pages 92 to 137.)

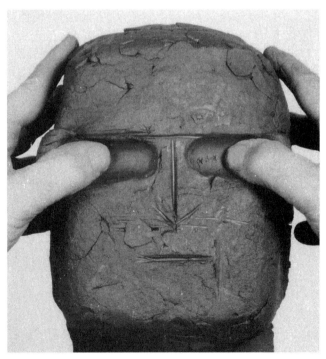

Holding my thumbs an inch apart, I push them into the head about half an inch, and pull them to the sides without removing any clay at this time.

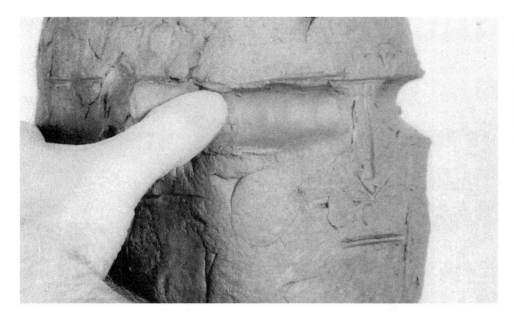

With my thumbs, I turn the corners at the side planes, continue back for about half an inch, and then remove the clay. Note that the eye socket starts on the front plane and ends on the side plane.

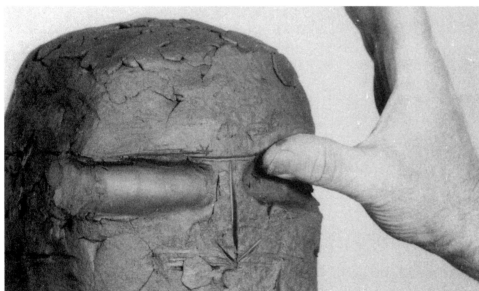

To round out the eye sockets, I place a thumb in each socket and gently push the top of the sockets upward.

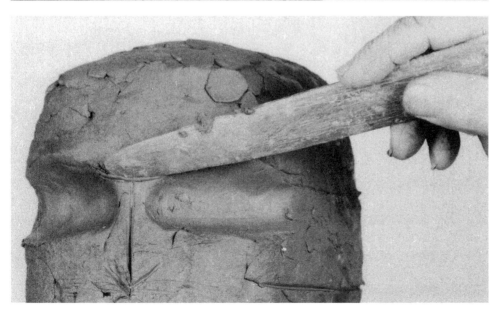

Using the wood modeling tool, I notch out some clay between the eye sockets at the top of nose to create the separation between the nose and the forehead.

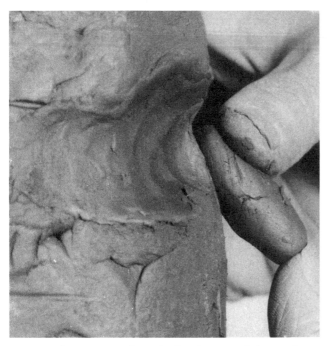

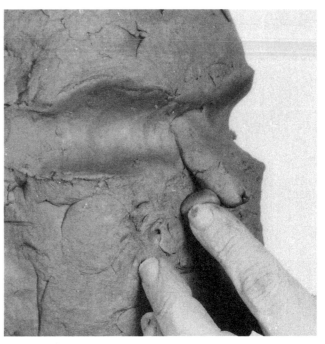

To form the nose, I roll a cylindrical piece of clay and press it into the notch between the eye sockets, extending it off the face plane at a 45-degree angle.

Adding smaller pieces of clay to the sides of the tip of the nose, I create a small wedge or triangular shape for the nostrils. I continue developing the sides of the nose by adding small pieces of clay and tapping them with the wood block (as in the bottom photo on page 23).

Holding the modeling tool on a slight tilt under each eye socket, I cut a flat plane across each side of the face plane that angles back, removing the pronounced edge of clay under each socket. I start this motion at the side of nose and end at the outer edge of the cheekbone.

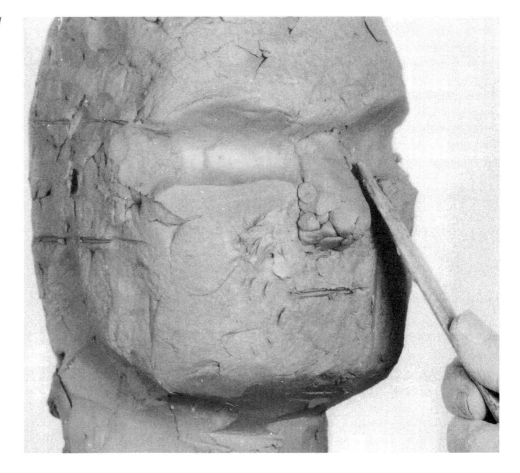

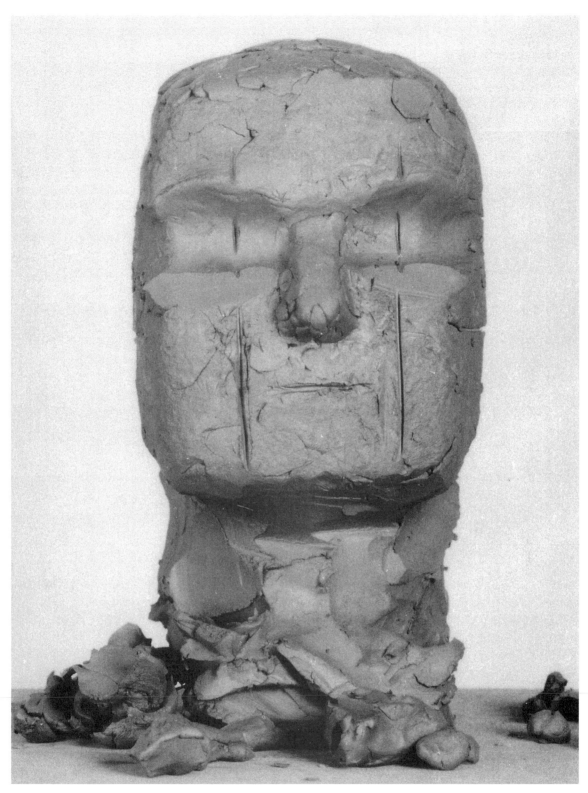

At this point, I check the symmetry of the head, making sure the sides are parallel to each other; the top of the forehead and the bottom of the chin should also be parallel to each other, with the nose in the center of the face plane and the brow and mouth parallel, as well. Using the thin edge of the wood modeling tool, I then draw vertical lines from the center of the eye sockets to the bottom of the face plane; these guidelines will usually pass through the corners of the mouth and define the width of the chin. Note that the top plane of the nose is broad and flat, and the side planes of the nose slant out slightly to the sides, creating a basic triangular shape.

To create the flat plane on the sides of the face between the cheekbone and the chin, I place my wood modeling tool on a 45-degree angle under the cheekbone and slice down toward the chin. Note that I don't cut beyond the guidelines for the chin.

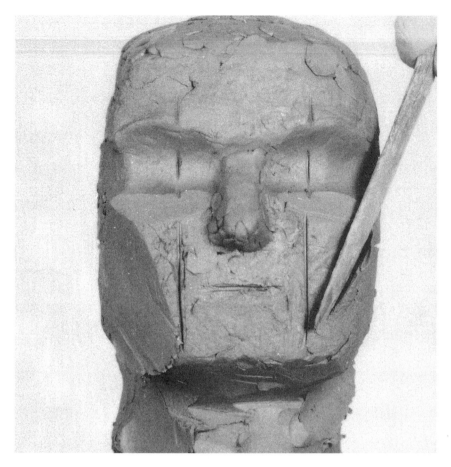

It's important to maintain the general, overall symmetry of the head and the symmetrical relationship of all the planes. With these two major planes, I've established the cheeks and chin on each side of the face.

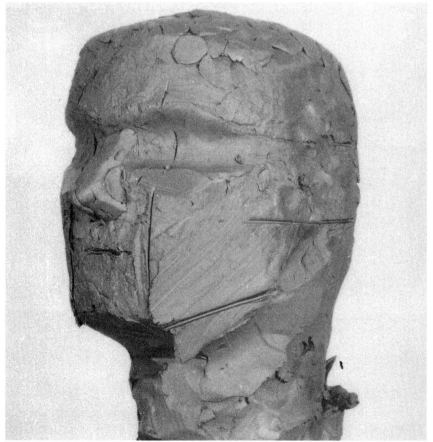

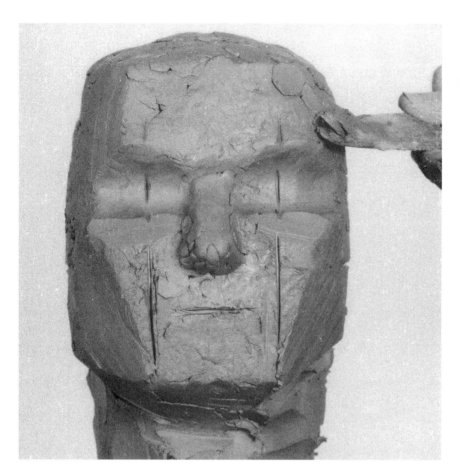

Here I cut planes, on both sides of the forehead, at 45-degree angles from the outer corners of the eye sockets to the top of the head.

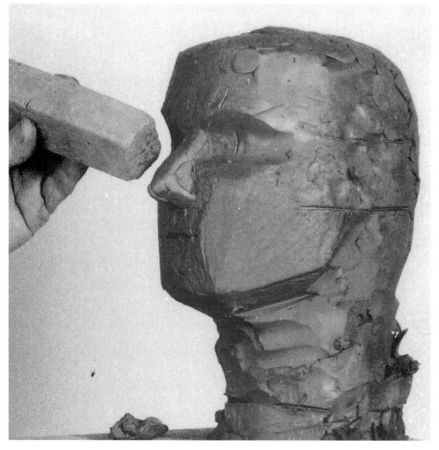

I also continue tapping the clay to firm and shape it.

To create the plane that establishes the back portion of the jaw, I cut from the ear canal on the side plane of the head down to the bottom of the jawline. This plane should slant in slightly toward the neck. It completes the plane structure of the cheek and jaw, and meets the cheek plane at the side between the cheekbone and the jawbone.

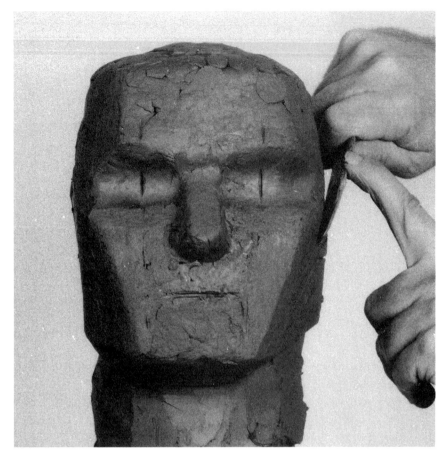

Here I cut a small plane down and in from the end of the front plane of the forehead at the brow line to the outside corner of the eye socket. This will create the curve of the upper outer contour of the eye sockets and temple areas on both side planes of the face.

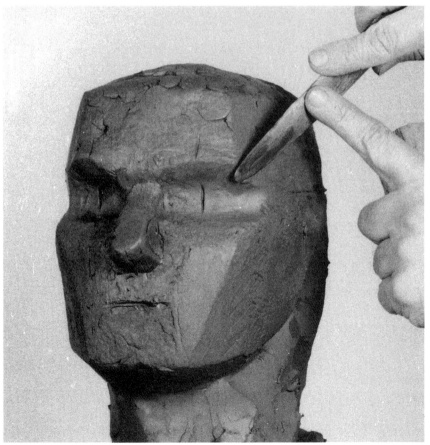

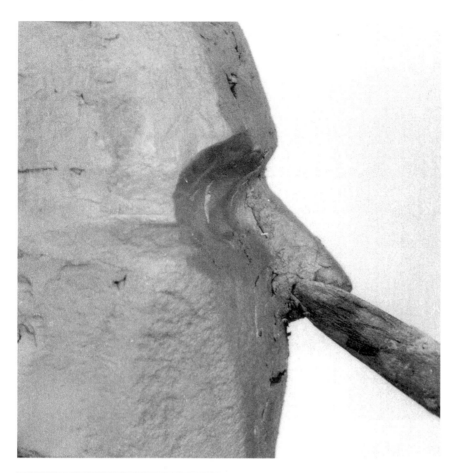

To finish the bottom plane of the nose, I press the edge of the wood modeling tool against the underside of the nostril on a slight angle upward.

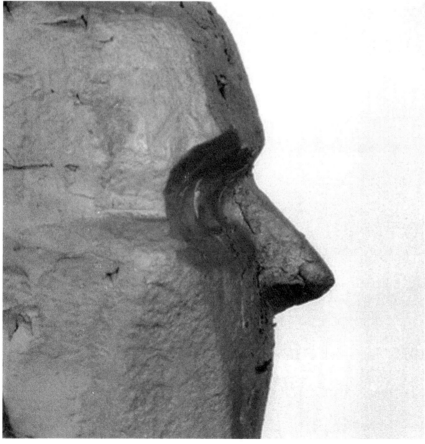

This is the time to check the profile. Notice how the forehead slopes back slightly, the eye socket has a fairly large and deep opening, and the vertical angle of the lower third of the face plane is fairly straight. There is also a plane (in shadow) going from the lower edge of the jawline on the side plane back (and under) toward the neck.

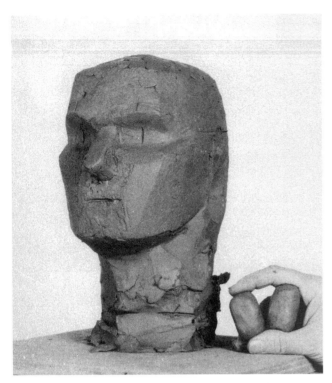

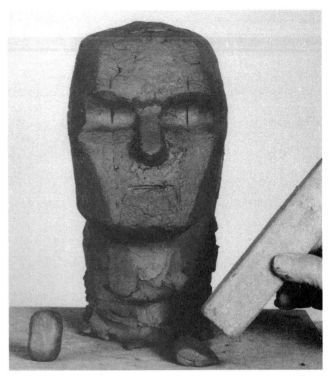

For the ears, I roll two cylindrical shapes, or coils, of clay slightly larger then the nose. (For more detailed guidelines on constructing the individual features, see pages 92 to 137.)

The shape of these ear pieces should resemble slices of apple or orange wedges. To flatten one side, I place the coils on the board and tap them with the wood block, holding the tool on an angle.

The ears are positioned between the brow and nose guidelines on the side planes of the head with the thin side of the wedge facing toward the front of the head. I trim the front of the ear and place it over the ear canal hole, tilting the top of the ear toward the back of the head.

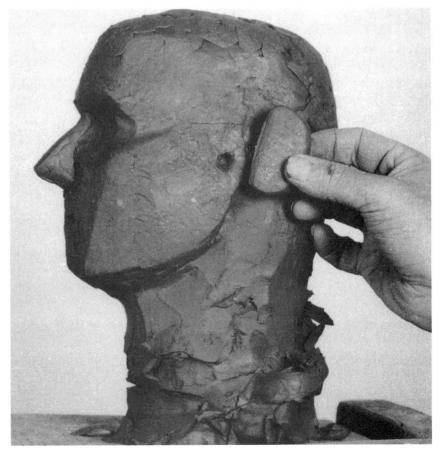

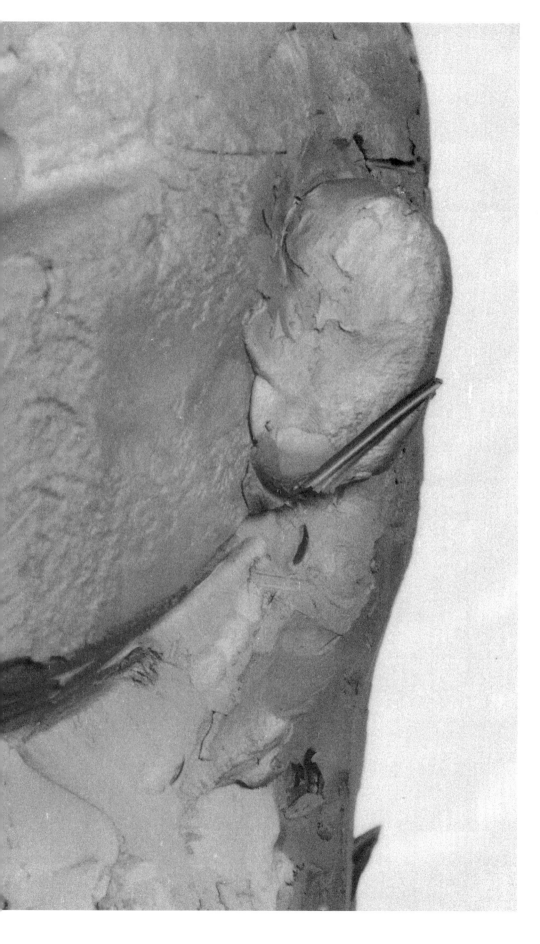

After attaching the ear, I blend the front and back of it to the head and finish shaping it by trimming the outer rim. I start trimming about two thirds of the way down the ear and cut toward the lobe. I shape both ears and check the symmetry before going any further.

To create the lower side planes of the back of the skull, I cut clay from behind the ears toward the back of the head on both sides.

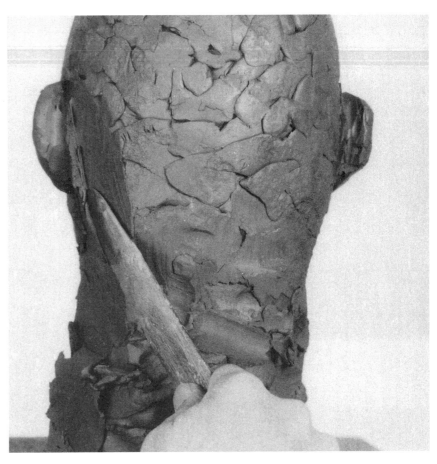

I then make a line level with the ears and parallel to the top of the head on the back of the skull.

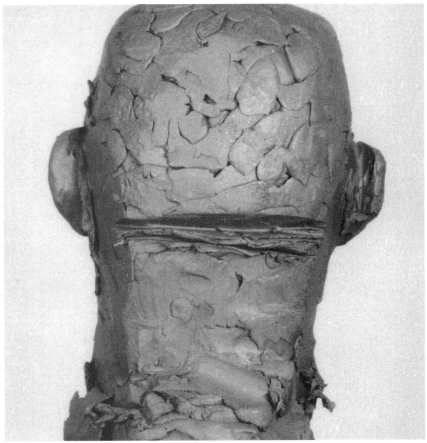

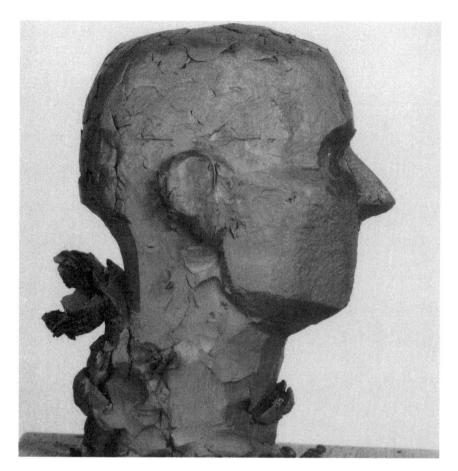

Cutting forward and downward along that line with the wood modeling tool brings out the structure of the back of the skull.

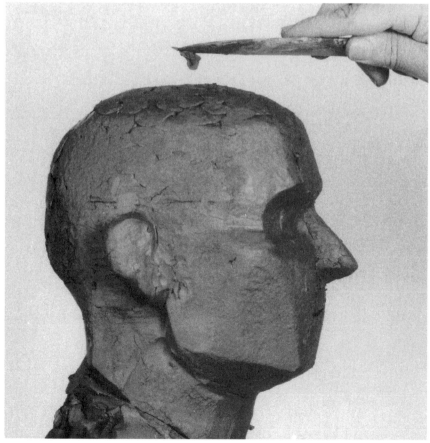

The highest point of the head is at the top of the skull. Adding small pieces of clay there with the modeling tool creates this slight contour.

Next, before building the planes of the mouth, I redraw the vertical guidelines of the chin. Adding small pieces of clay under the nose with the modeling tool gives this section of the face plane a curved or semicircular shape.

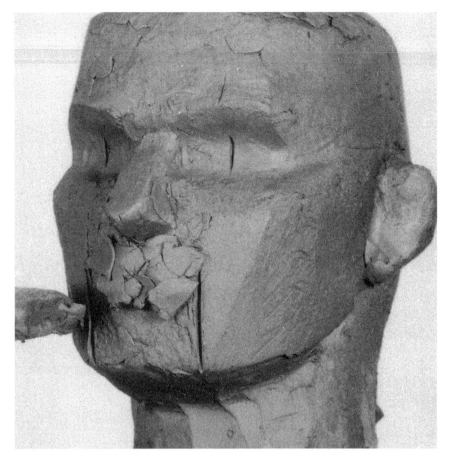

After tapping the clay under the nose down with the wood block, I continue shaping the mouth section with a rake tool. (See page 45 for additional information about this tool.) I pull the serrated side of the tool along the surface of this section, pressing gently enough to rake and blend the new clay into adjoining areas. It helps to use a cross-hatching motion, until an evenly graded surface, free of lumps and bumps, has been achieved; this modeling technique is referred to as pulling the form together.

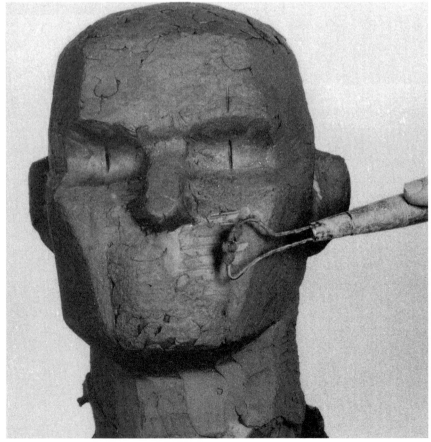

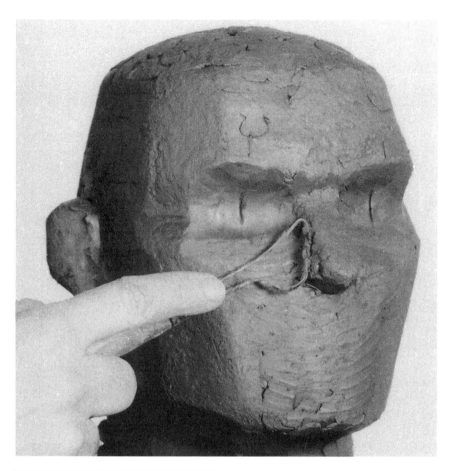

I also pull the form of the nose together along the side and top planes.

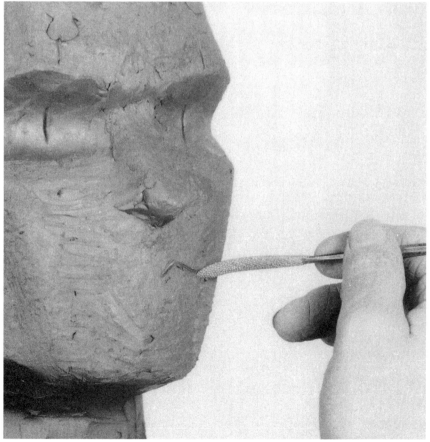

At this point, I redraw the vertical guidelines from the center of the eye sockets down to the chin to establish the width and corners of the mouth. (You could also redraw the original horizontal line for the mouth to use as a guide when drawing the planes of the lips.) Using the rasp tool (see page 45), I begin to draw the curved line of the upper lip out to the corner.

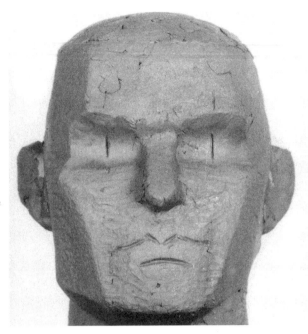 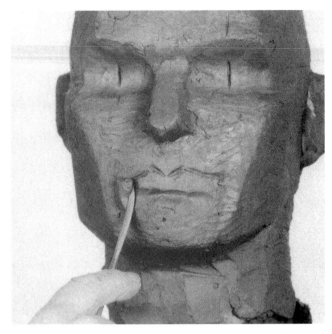

I repeat this on the opposite side of the mouth area. Note that the corners of the mouth should curve around the jaw and end on the side plane of the head just below the nostril. (See the bottom photo on page 34 for another angle). To define the form and planes of the lower lip and the top of the chin, I've drawn a horizontal line about half an inch below the upper lip using the rasp.

To create the side planes of the lower lip I place the rasp on the front plane of the lip (about a third of an inch from the outside corner of the mouth) and cut back to the outside corner. I also scoop out the clay under the top lip and leave dimples in the corners. (You can see this clearly in the bottom photo on page 34.)

To broaden the upper lip, I push upward on this plane with my rasp and slide the tool across the plane to the corner of the mouth, following the shape of the lip.

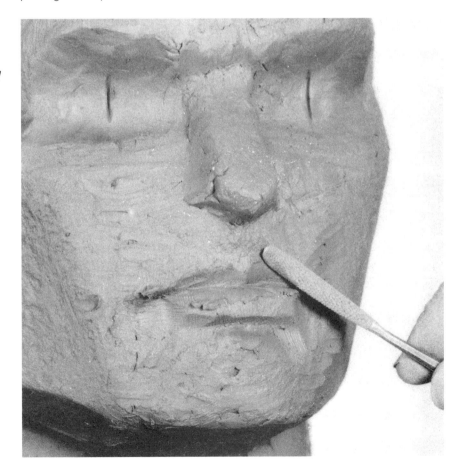

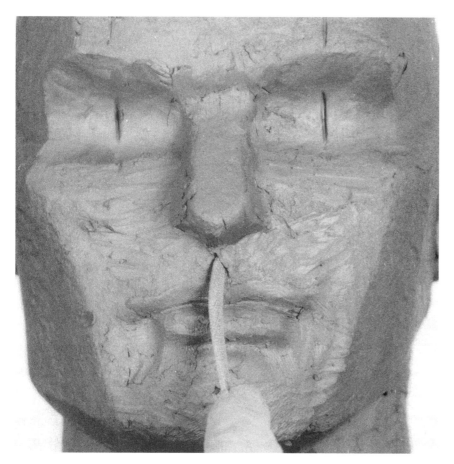

The shallow groove between the nose and upper lip is the philtrum. To create this, I scoop out clay with the rasp, holding it in an upright position and using the side of the tool.

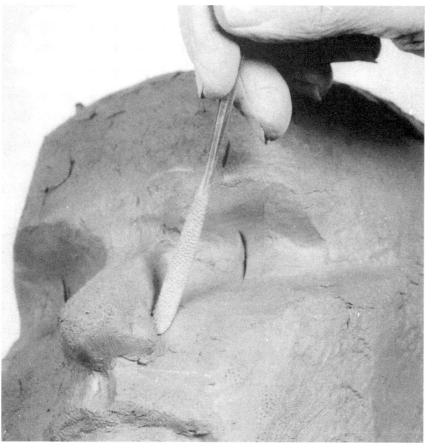

To form the back plane of the nostril, I place the round end of the rasp behind the top of the nostril. Bringing the tool down and under the nostril in front, while pressing back gently against the face plane, I scoop out a small amount of clay. (You can see the angle of this plane well in the photos on page 34.) You can see that the chin is also established here with small planes cut on both sides.

Before creating the eyeballs, I check the openings of the sockets for equal depth. The round pieces of clay for the eyeballs should be small enough to fit into the socket without protruding beyond the brow or cheekbones. Tilting my thumb upward, I press the balls of clay gently into the center of the sockets. Note that the front plane of the eyeball is flat and slants back a bit from the top to the bottom of the socket.

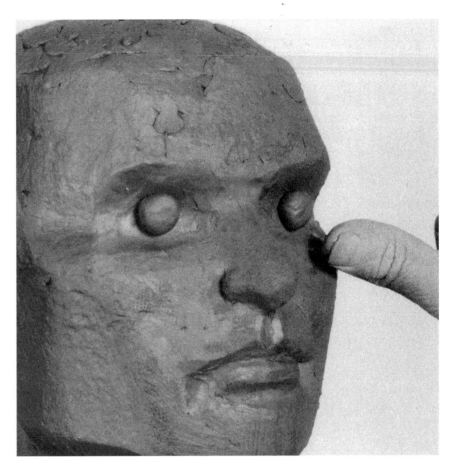

Here you can see the angle of the eyeball. I also press small balls of clay against the left and right sides of each ball to fill out the eye.

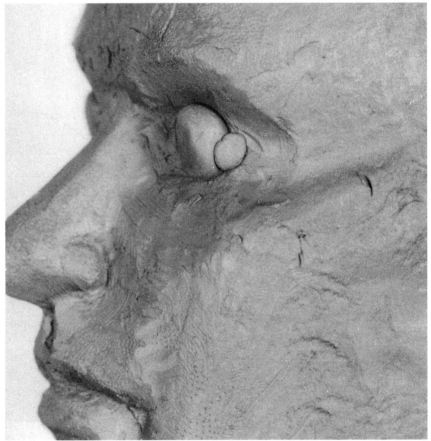

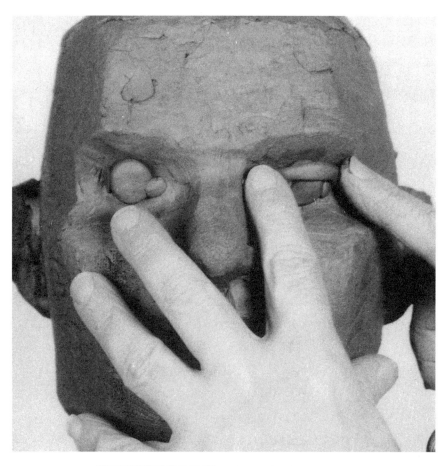

To create the upper eyelid, I roll out a piece of clay long enough to stretch from the nose to the outside corner of the eye socket. I place the middle of the clay strip over the top of the eyeball and, using my index finger, gently press it around the eyeball.

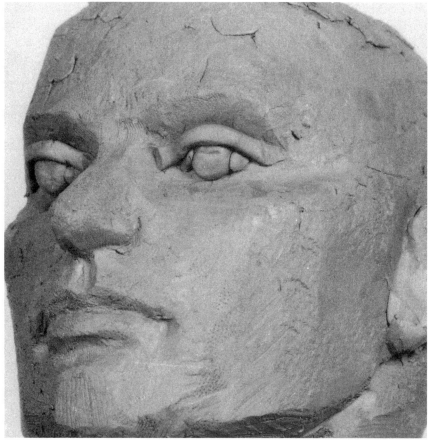

Note that the outside corner of the upper lid sits a bit higher and deeper in the socket than the inside corner of the lid. Also, the entire lid doesn't extend beyond the opening of the socket.

Here I blend the eyeball and lid with the broad side of the rasp by gently pressing the top of the eyeball up to the lid. (You would blend the upper lid to the top plane of the socket using this same modeling technique.) Before putting on the lower lids, I compare the eyes to make sure they are the same size and shape.

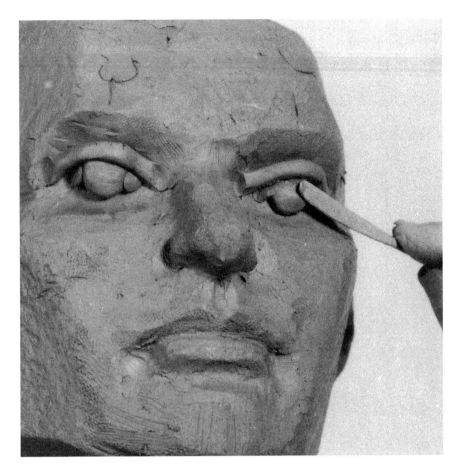

The lower lid is formed by placing a small strip of clay horizontally under the center of the eyeball. Note that the strip is shorter than the length of the eye socket.

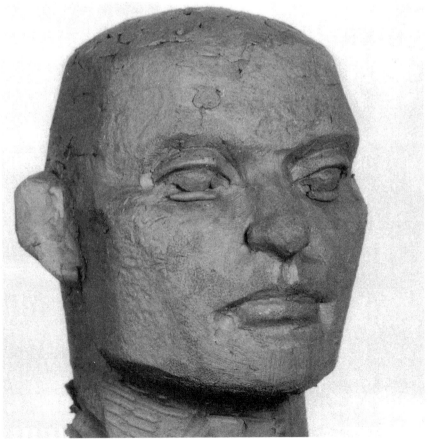

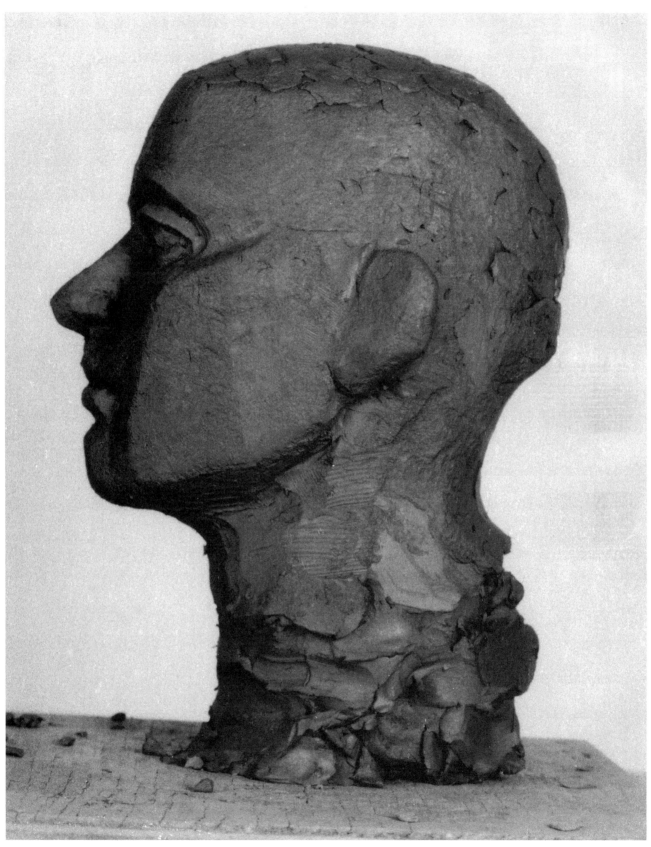

To complete the formation of the eyelids the lids are blended to the eyeballs and the face plane wherever they meet.

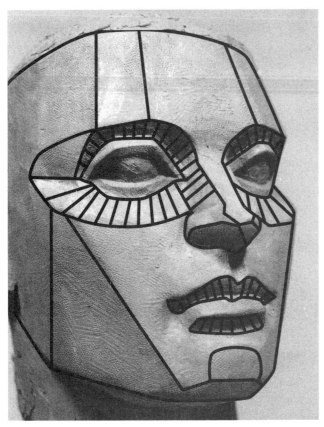

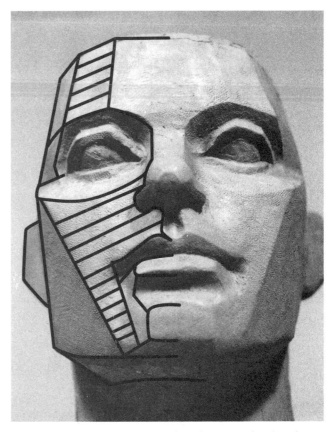

At this stage the head clearly displays all the major planes of the face. I've outlined them so that you can see where they break (meet and change direction). The highlighted and shaded planes create fascinating designs and patterns. Note how the broad front plane of the forehead narrows at the bottom to become the top plane of the nose. The plane of the eye sockets, between the upper eyelids and the forehead, continues alongside the nose and the face plane just under the eye.

From this angle, you can see the planes under the chin, as well as those on the front and sides of the head. The striped face plane and the plane of the forehead slope in the same direction toward the side of the head.

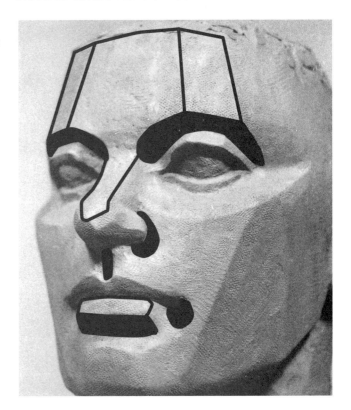

Here, I've highlighted the planes around the corners of the mouth, behind the nostril and under the nose (the philtrum), and under the lower lip and the brows. I call these shaded areas transitions; they give depth to the form.

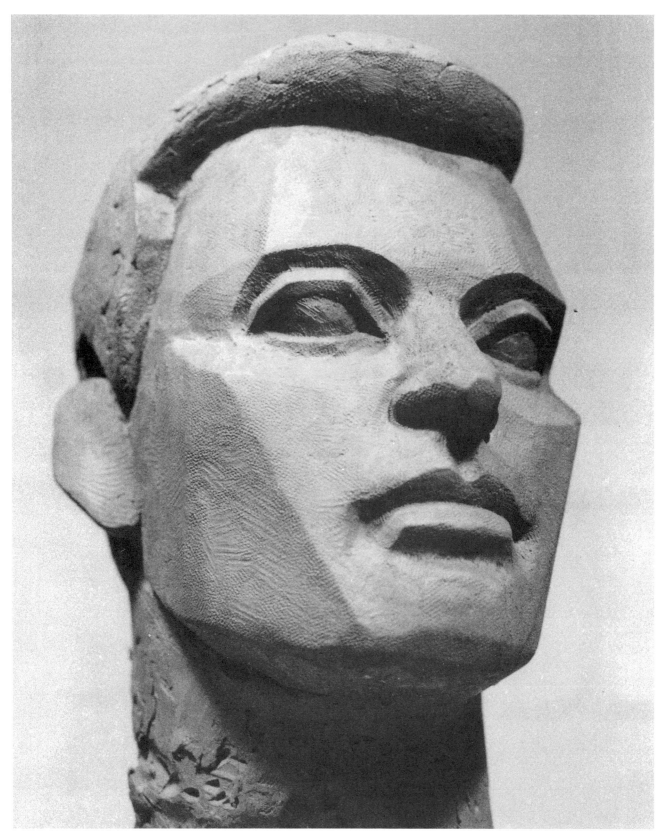

The hair is treated as a mass. I built up the hair on this portrait by adding rounded pieces of clay to the top, sides, and back of the head. Follow the contour of the forehead around the front and down the side behind the temple to the ear for the hairline.

The hair mass has planes on the front, sides, and top. Note also how the edge and plane of the upper lip mirror the edge and plane of the upper eyelid and eye socket.

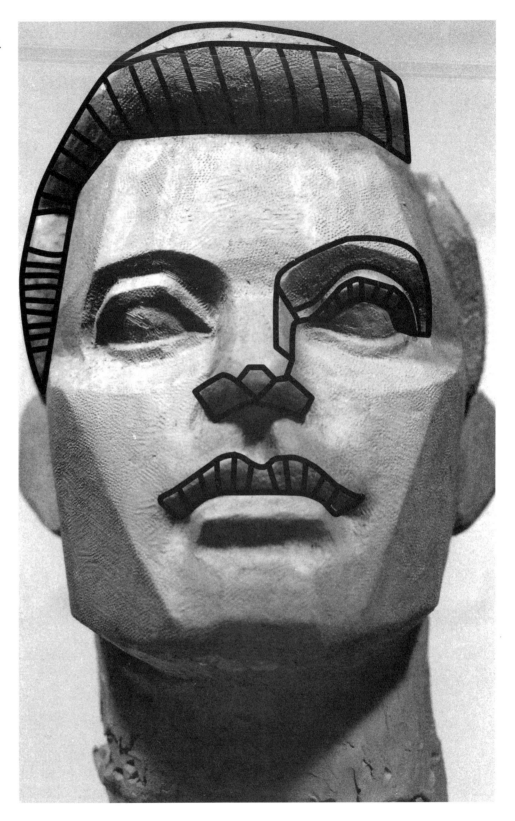

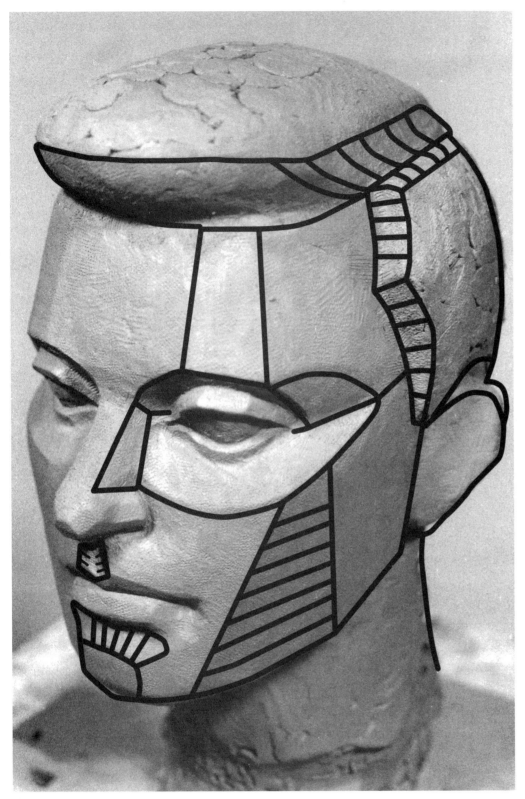

Here you can see some other angles of the hair and part, as well as of the ear, side of the face, and chin. The line starting at the nose, going around the eye socket to the temple, and around the cheekbone back to the nose has a wonderful shape.

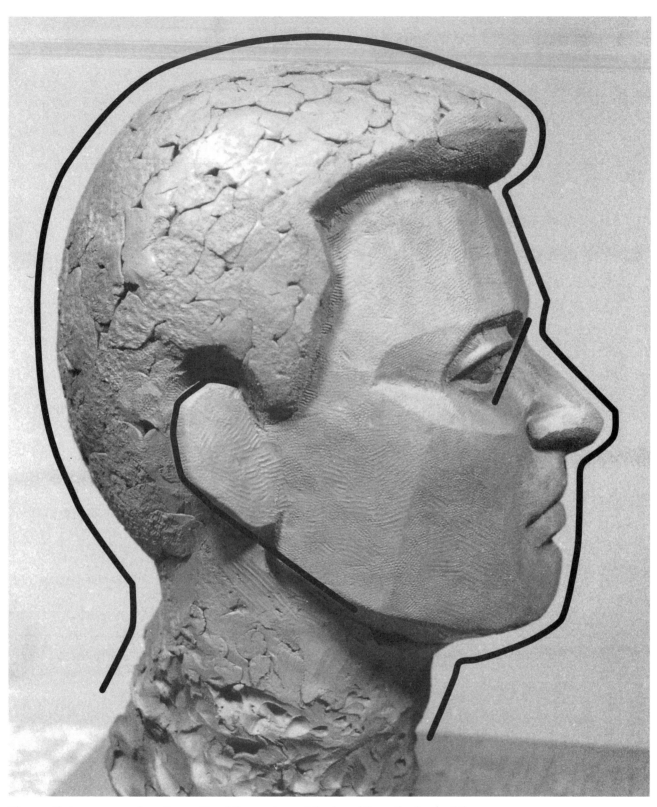

The profile is very revealing. I've outlined the contour of the head from the back of the neck to the front of the forehead. Note the slope of the forehead, the angle of the nose, and the angle from the base of the nose to the bottom of the chin. The eye slopes back from the top lid to the bottom one.

THE SCULPTING PROCESS

When sculpting a portrait from a live model, you develop the sculpture in stages, beginning by forming a simple block of clay for the foundation, then slowly progressing to the planning and placement of the features, and culminating in the refinement and texturing of the piece. During this process, you learn how to use the model as your point of reference and how to make the most of your tools, including your hands.

MATERIALS AND TOOLS

Most beginning sculptors like to use their fingers to model the clay; after all, this is a tactile medium. However, the use of various implements in combination with your hands often yields the most succesful results, maximizing your efforts. Tools can, for instance, help you create hard edges and round forms; they can also broaden your capability to sculpt details, enable you to explore and develop a variety of textures and surface treatments, and allow you to model precise shapes and planes.

Once you acquire a feel for the clay, and for sculpting from the live model and using your tools to express your vision, you'll begin to master your medium. You will sculpt with more confidence and joy, and, ultimately, your creations will bear your distinct signature and become true personal artistic expressions.

CLAY

The water-based clays that I use are available in a wide variety of colors, the most common of which are gray, brown, and red. The texture of the clay varies as well, from a silky quality that's smooth to the touch to a moderately coarse feel. Also available is clay mixed with grog (fired clay that has been ground up); when mixed with clay, grog reduces shrinkage. Clay with grog has more body than plain clay and has a gritty texture.

Smooth clays, without grog, are better suited for finer, more detailed works requiring smoother finished surfaces, while clays with grog work well for sculptures that have large, simple shapes and more pronounced surface textures. Which clay you choose is really a matter of personal preference, and you should try them all for yourself. I enjoy working with both types. For the portrait that I sculpt here, I used smooth red clay.

Clay comes ready-mixed in 25lb. bags and requires no preparation. Whether drying naturally or being fired, water-based clays tend to dry to a lighter color than when they're moist. When working with the clay, spray it with water

occasionally to replenish its moisture level and maintain its plasticity. Also, be sure to cover any unfinished pieces carefully with plastic wrap when you're not working on them to prevent them from drying out prematurely.

Once you're ready to fire your piece so that it is permanent, hollowing and drying the sculpture beforehand will ensure successful firing; don't be concerned about air pockets in the clay. Clays fire at different temperatures (or cone numbers), which you'll need to find out when you purchase them. You can purchase clay at most art, sculpture, and ceramic supply stores (see Resources), and 50lbs. is enough to create a life-size head, including the neck and hair.

ARMATURES

When sculpting a life-size head in clay, use, at the very least, a single-post armature. The armature supports the clay and guarantees that your piece will remain standing until you're finished working on it. By drilling a 1-inch hole in the center of a 14 x 14 x ¾-inch wood board and tapping a 10 x 1-inch round dowel into it, you can easily construct your own armature.

If you don't want to drill a hole, you can nail the dowel to the board through the bottom of the board. Once you have your armature, you can use a *C-clamp* to secure it to the table top or modeling stand on which you're working. A *tripod modeling stand* has wheels for mobility, and the adjustable pole makes it easy to find the best height for your sculpture. The supporting board provides an adequate work area, and the stand can safely support approximately 150lbs. of clay.

THE RUBINO 3-IN-1 HEAD ARMATURE

Another support option is the RuBino 3-in-1 Head Armature. Developed by Peter Leggieri, I recently designed this armature, which is available exclusively at Peter's Sculpture Supply in New York (see Resources). It

has a 10-inch threaded pipe screwed into a flange that is attached to a 14 x 14 x ¾-inch formica-covered board. A removable 6-inch wire loop can be screwed to the top of the pipe or to the flange. The pipe, used alone, is good for life-size or smaller heads intended for firing; the pipe and wire loop, used together, are good for larger than life-size heads, with neck and shoulders included.

If you want to sculpt a portrait that tilts or bends in a certain direction, you can use the wire loop by itself, attached to the flange. If you want to mold and cast your piece, you can leave the armature in the sculpture; when firing a piece, however, you must remove the armature during the process of hollowing the head (see page 138).

MODELING AND TEXTURING TOOLS

The sculpting process of adding, subtracting, and shaping clay requires a few basic implements. The *wood modeling tool* is useful for doing all these things and is made from rose wood—a hard wood that resists warping and splitting. For better modeling results, I sometimes sand the sides and edges of my wood modeling tools to make them thinner and sharper. Also important for modeling is the *riffler rasp,* which you use for creating details and shaping forms by pressing it into the clay.

The *serrated wire loop* or *rake* tool functions basically like a rake (pulled along the surface of the clay) to evenly grade the surface of the sculpture and pull the overall form of the piece together. It's great for shaping the clay. The *wood block* is also good for shaping clay, which you can do by tapping the block over all (or just certain sections) of

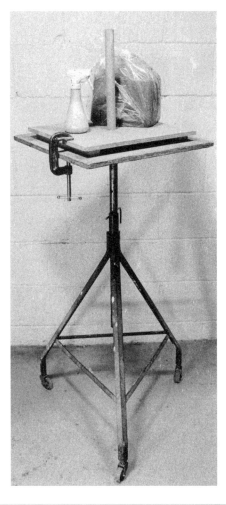

Pictured here: modeling stand with tripod legs, round armature post supporting board, tripod pedestal, water sprayer, red water-based clay (25lb. bag).

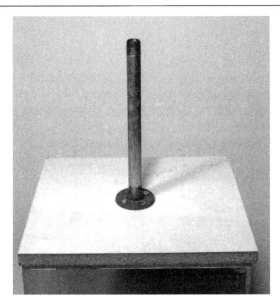

The RuBino 3-in-1 Head Armature is an adjustable support system. Here, you see the 10-inch pipe threaded into a flange attached to a 14 x 14 x ¾-inch formica-covered board.

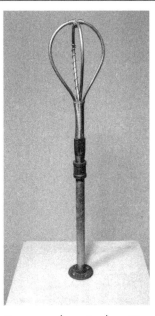

You can also attach a 12-inch wire loop to the top of the pipe.

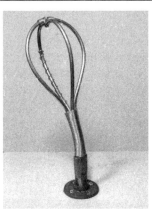

Another possibility is to attach the 12-inch wire loop directly to the flange, without the pipe. The wire loop is also flexible enough to be tilted in various directions if you want your sculpture to lean to a certain side.

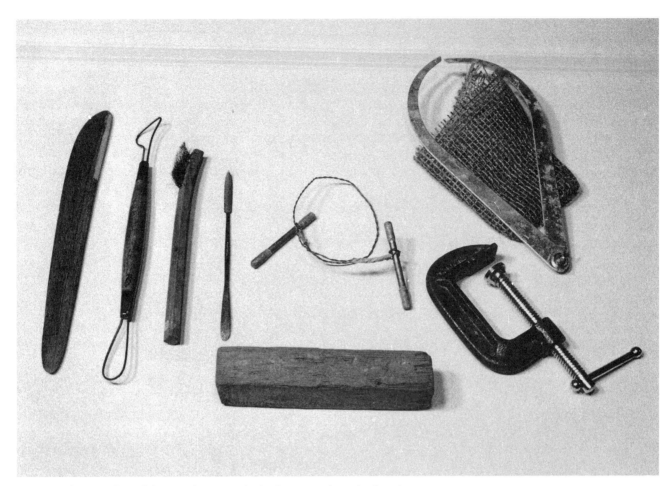

Left to right: wood modeling tool, serrated wire loop or rake, wire brush, riffler rasp, cutting wire with handles, burlap (1 square foot), calipers, C-clamp, and wood block.

your sculpture. *Burlap* is handy for creating surface texture on your sculpture; you do this by bunching up the burlap in your hand and blotting the surface of the clay.

MEASURING TOOLS AND OTHER ITEMS
Calipers (seen in the upper right corner in the photograph above) are a measuring device that help achieve correct proportions in a piece. You use them by first loosening the screw joining the two arms, then holding the arms up to the area (on the live model) that you wish to measure, and then tightening the screw to secure the arms in that position. You then hold the calipers (still in this position) up to the corresponding area on your sculpture to compare the measurement.

Also necessary is a *cutting wire with handles* for cutting usable-sized pieces of clay from the main block of fresh clay, and for cutting your portrait during the hollowing process (see page 138). You should have a *wire brush* as well, to remove dry clay from your tools, especially from the riffler rasp.

SCULPTING FROM THE LIVE MODEL
As far as traditional sculpture is concerned, it could be said that sculpting a portrait from life is a measure of a sculptor's ability. Throughout the course of history, artists have created portrait busts (showing the head, neck, shoulders, and top of the chest of the subject) to immortalize the rich and famous in their society. Today, sculptors at all levels enjoy creating portraits of family members, friends, and even just people with interesting faces. It is a way to express one's deep feelings about one's subject in an aesthetic form, and it can also be very theraputic.

Sculpting from a live model, as opposed to working from photographs, allows the sculptor to see the many nuances and subtleties of the human face. The sculptor can freely measure and observe the model from many views and, by doing so, begin to appreciate the complexities and proportional relationships in three-dimensional art.

Each face has unique identifying features and can express a range of human emotions. Sculpting a portrait from the live model is a process unlike any other. What a

challenge it is to capture the character, likeness, expression, spirit, and essence of your model in a sculptural form. How exciting and exhilarating to work within inches of the model! And, how rewarding when you achieve your goals!

If both you and your model are beginners to the sculpting process, you may feel awkward at first. However, it should take you only a few minutes time to get past this. To set up your work area, seat the model on a high stool with a swiveling seat, if possible. Place your modeling stand or table, with your armature C-clamped to it, between you and the model. Adjust your modeling stand so that it is eye level with the seated model. Leave space around your model, because you'll need to move around the model with your stand, as well as turn the model frequently since all views are important.

THE FOUNDATION

This is the most important element of your sculpture. You must achieve a well-proportioned block shape for the head mass and cylinder shape for the neck before moving on to sculpt the features. This foundation will be the basis of your piece.

When applying clay to your armature think of creating a solid form that grows and expands from the inside, like a balloon. As you build up the head mass, don't squeeze the clay to shape it; it's better to press the pieces together gently first, and then tap the clay with your wood block. This technique will help you to form a solid, symmetrical block, and once you establish the correct proportions for this head mass, you can proceed to developing the facial features.

To begin, position your clay and modeling stand pedestal between you and the person you're sculpting (this is your subject and may also be referred to as the model). Raise the modeling stand to a comfortable working height; eye level is a good level at which to begin. You need enough space to move freely around your subject. Using the clay cutting wire, start cutting pieces of clay from your 25lb. block. These pieces should be 6 to 8 inches in length and 1 to 2 inches square in width and depth.

Roll pieces of clay into approximately 6 x 2-inch cylinders or sausage shapes. Hold the clay cylinders vertically, and press each piece to the armature; start at the bottom and work your way up, creating the cylindrical shape of the neck first. Work all around the post. You're building a solid form, so don't distort the shape of the neck by squeezing the clay too much.

Next, build up a rectangular block shape, for the head mass, on top of the neck form. Build up all the surfaces of the block, which are called planes. Each plane will eventually contain various elements (or features) of the head: the hair mass on the top, back, and side planes; the ears and sides of the jaw on the side planes; the facial features on the front plane; the bottom of the chin and jaw on the bottom plane; and the back of the skull on the back plane.

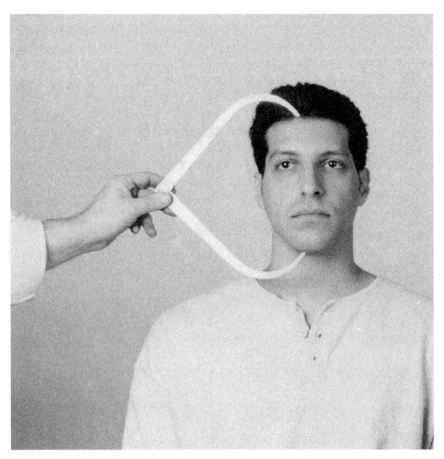

Use the calipers to measure the height of the front of the face, from the chin to the top of the forehead. Measure your subject, and tighten the screw or wing nut at the joint of the calipers to lock it in that position.

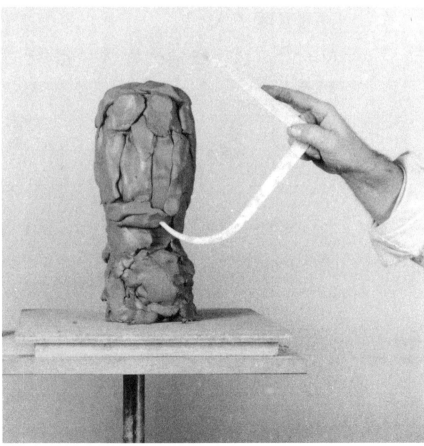

Hold the calipers up to the front plane of your sculpture to see how the length compares. If necessary, add pieces of clay to the head mass with the wood modeling tool, or cut clay off, also with the wood tool, if the head mass is too big.

Also use the calipers to measure the depth of the model's head, from the front of the forehead to the back of the skull. Notice that the depth of the head is the same as the height. Check the depth of the model's head against that of your sculpture, and add or subtract clay as needed.

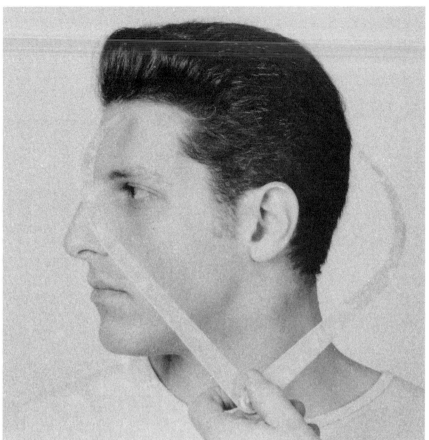

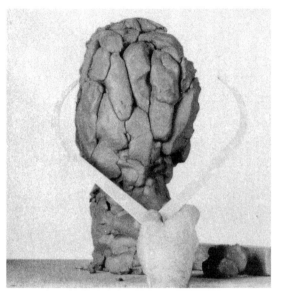

Measure the width of the model's face across the cheekbones, which is the widest point across the front plane of the face. Compare this measurement to the height and depth; notice how much smaller it is. Then, measure the sculpture, and add or subtract clay as needed.

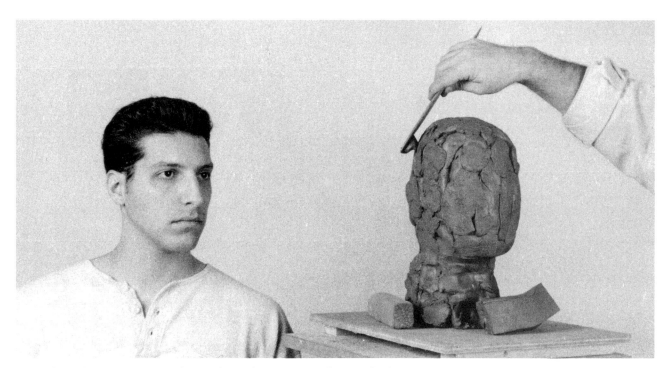

Have the subject turn from side to side so that you can observe the head from all views. Check the planes, symmetry, shape, and proportion of the sculpture, comparing them against the live model. Add small pieces of clay to fill out the form of the head mass. Note that you should always turn your sculpture to the same position as the subject when sculpting.

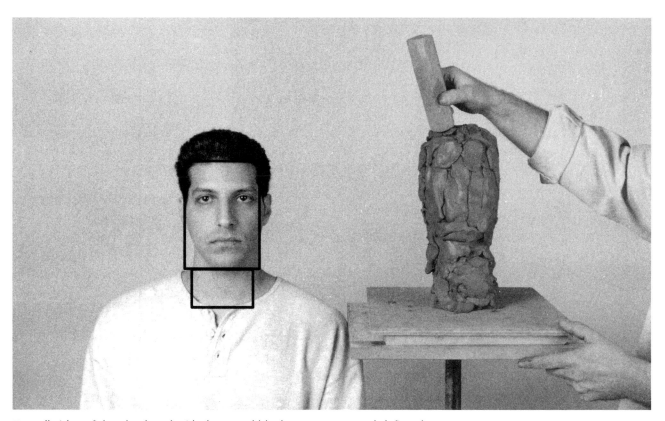

Tap all sides of the clay head with the wood block to compact and define the plane structure. Keep the sides of the clay block parallel to each other.

Using the wood modeling tool like a knife, cut the clay back into the neck, at the bottom of the block, to define the bottom of the chin.

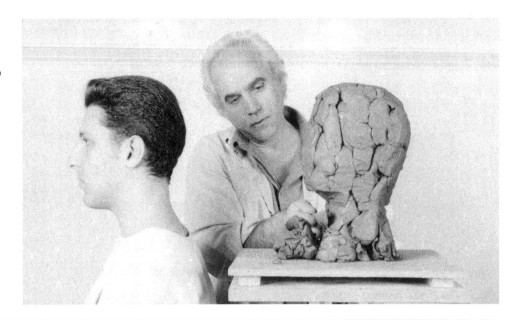

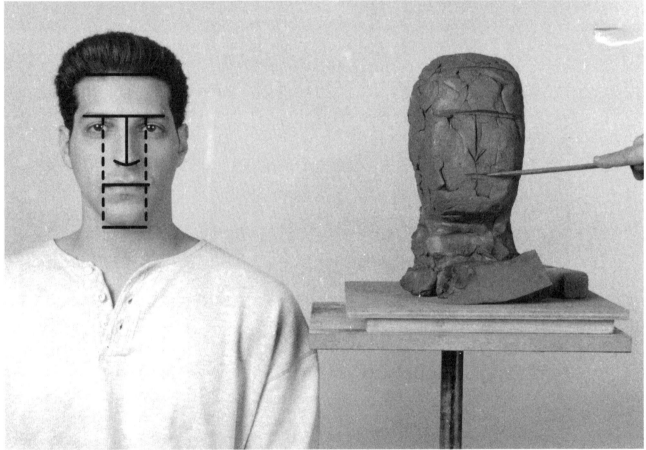

To establish the eventual placement of the features, divide the front plane of the sculpture into thirds using the edge of the wood modeling tool to mark the clay. For the first third, start at the top of the forehead, go one third of the way down the front plane, and draw (score) a horizontal eyebrow guideline parallel to the top of head. For the second third, draw a vertical guideline for the nose another third of the way down the sculpture, *perpendicular to the brow line. This line should be in the center of the head. Draw a small v at the end of the line. For the final third, draw a line for the mouth in the center of the lower third section, parallel to the brow. This line should be as wide as the distance between the center of the eyes (you can approximate this distance at this point, since the eyes haven't been sculpted yet). Once you have done this, stop and check the position of the lines.*

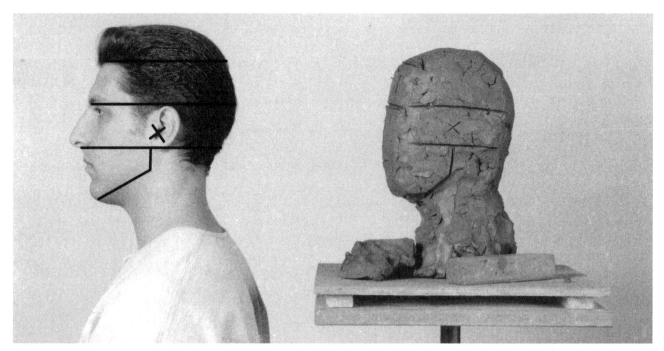

On both side planes draw two parallel horizontal lines to delineate the middle third of the head from front to back. The ears are located in this middle third, and these are the guidelines for the top and bottom of the ears. Note that the top lines on the side planes should be even with the top line on the front plane, and the bottom lines on the side planes should be even with the line for the end of the nose on the front plane. The ear canals (the holes of the ears) are located in the center of the side planes. Mark each location with an x.

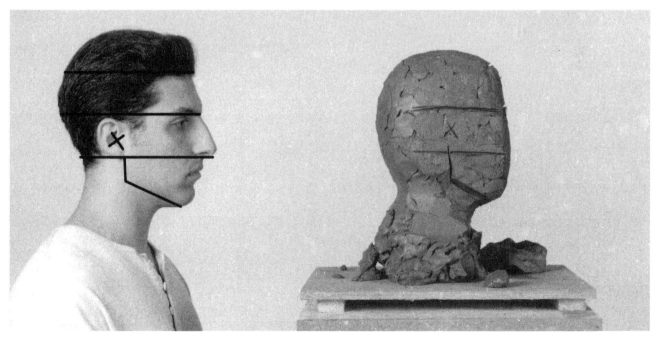

The jaw also begins on the sides of the head, just below each ear canal. Start the jawline by drawing a vertical line down about 1½ inches in length at a 90-degree angle to the lower ear guideline. Finish by drawing a slanted line, at a 45-degree angle, from the end of this line forward to the chin.

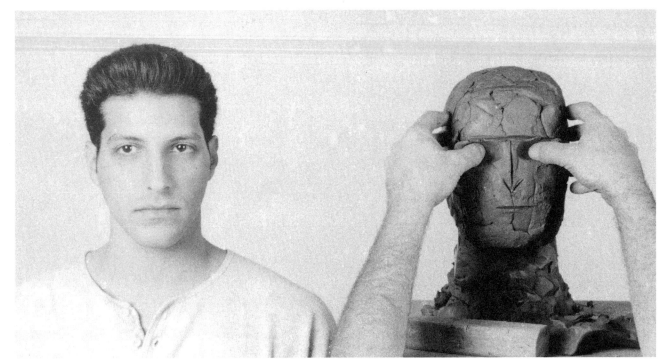

The eye sockets are square openings with rounded corners. They start on the front plane and end on the side plane. To form them, place your thumbs just below the brow line, 1 inch apart. Push thumbs into the head mass about half an inch deep, and pull them across the face plane under the brow line and toward the outer corner of the face plane.

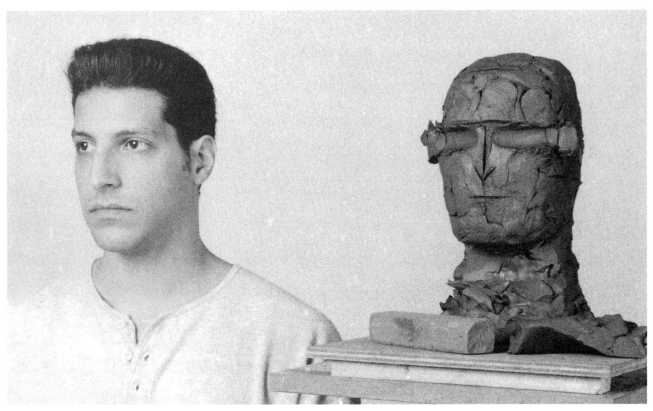

Turn your thumbs around the outside corner of the face plane, and remove excess clay as you turn the corner.

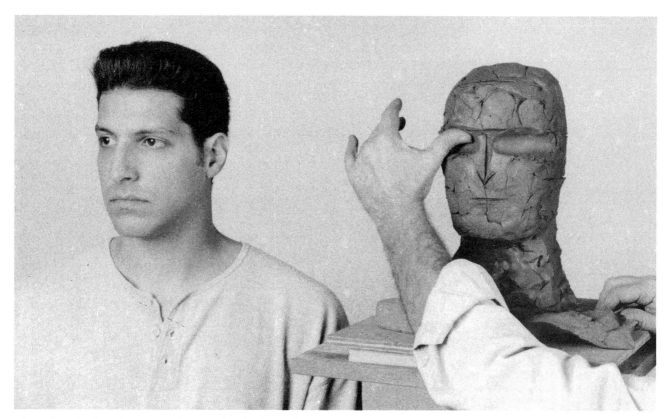

Place thumbs into the eye sockets under the brow line, and push up to arch the brow.

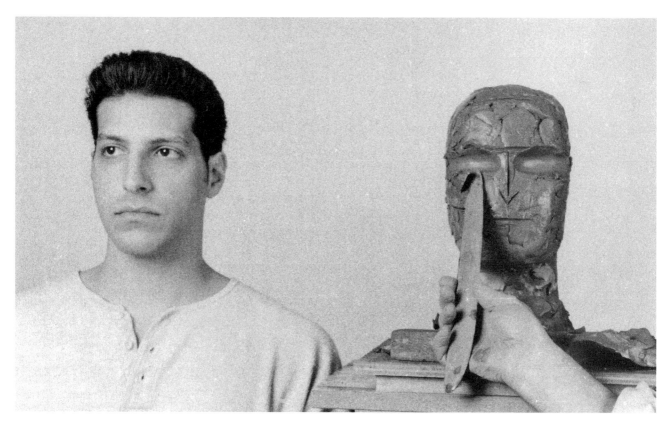

Using the wood modeling tool, cut the bottom edge of one socket to create a sloping plane between the nose and cheekbone.

*Repeat on the
other side of the
face plane.*

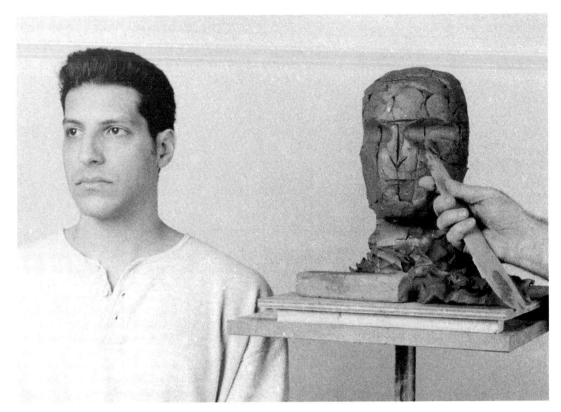

Have the subject turn to one side. Observe the side angle of the face from the cheekbone to the chin, which I'm highlighting here with the modeling tool.

Draw vertical guidelines down from the center of each eye socket to the bottom of the chin. These lines will denote the width of the mouth and chin. Using the wood modeling tool in a slicing motion, create a plane at a 45-degree angle between the front and side planes of the head from the cheekbone down to the chin. Don't cut beyond the chin guidelines.

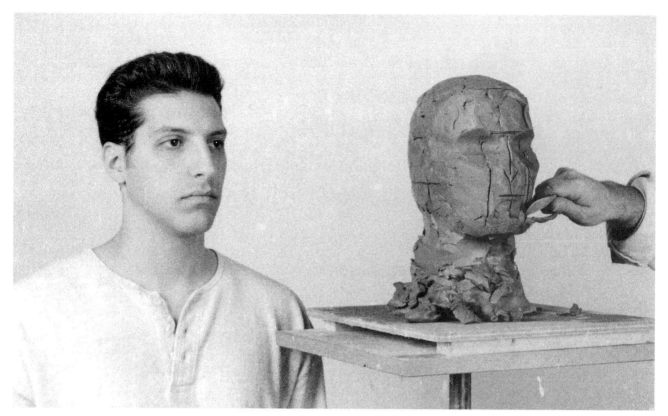

Repeat this procedure on the other side of the face plane to complete the plane structure of the cheeks.

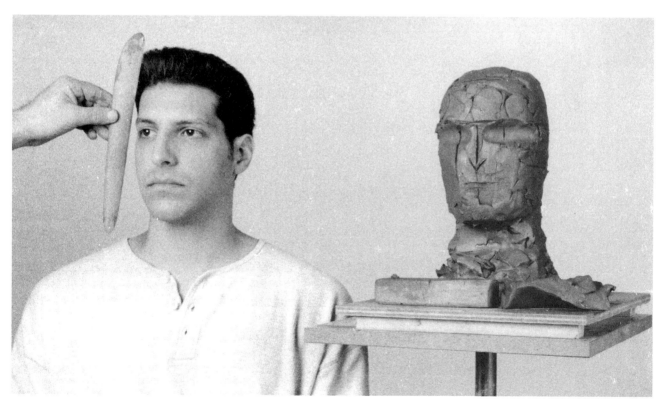

Have your subject turn 45 degrees (from center) to the side, and observe the slope of the forehead (highlighted here with the wood modeling tool) from the outside corner of the eye socket to the top of the head.

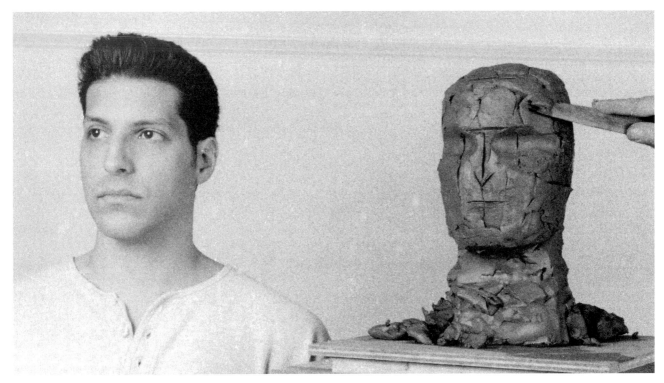

With the wood modeling tool, create a plane at the top outside corner of the eye socket. This plane travels upward to the top of the head. You should hold the tool at a 45-degree angle from the front to the back of the head. Do this on both sides of the form.

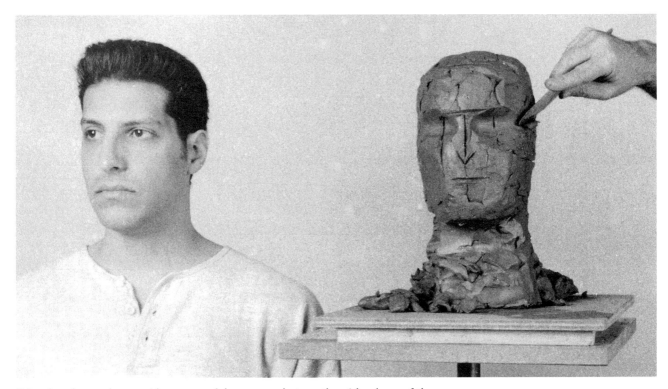

Trim the clay at the outside corner of the eye socket, on the side plane of the head. Place your riffler on the side of the socket at the brow line and cut down to the cheekbone. From the front view the cheekbones should be wider than the upper outside corners of the eye sockets.

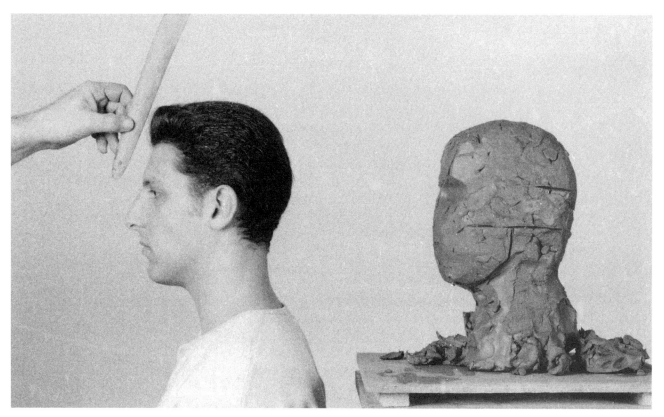

Turn the subject and your clay model to the profile. Observe and compare the slope of the forehead from the bridge of the nose to the top of the head.

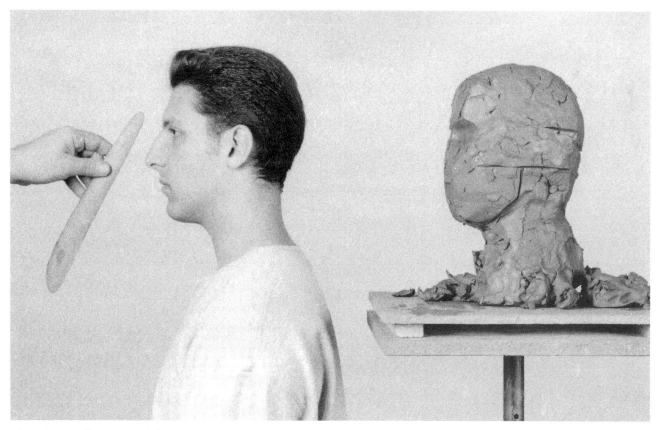

Also observe the angle of the nose from the brow to the tip.

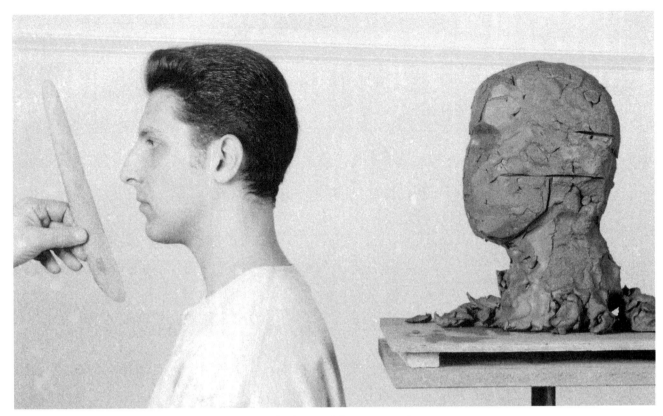

Observe the angle of the mouth and chin from the base of the nose to the bottom of the chin.

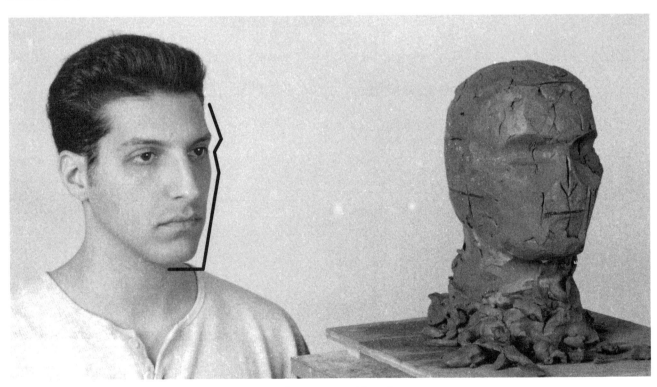

View the subject and your clay model together, in the same position, from above eye level. Observe the side angles, planes, and the shape of the head you've created, and compare them to the live model. Add or remove small pieces of clay where needed, just as we've been doing all along.

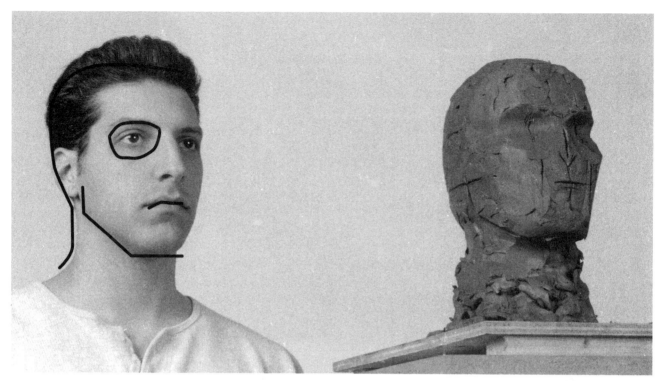

Now view your subject and clay piece from below eye level. Continue to observe and compare the angles, planes, and shapes of the live model to the sculpted form. The character of the subject should begin to emerge in your piece during this stage of development.

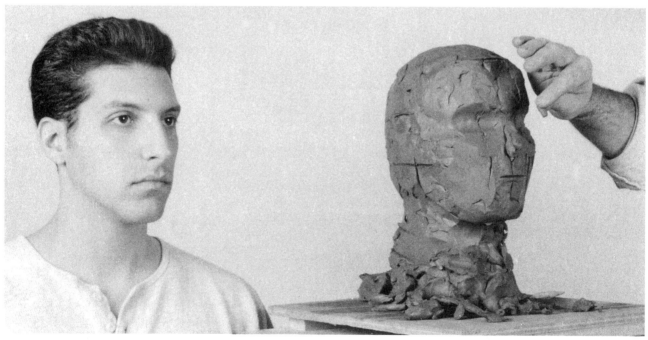

Create a notch in the clay between the bridge (top) of the nose and the forehead. This area is called the glabella. Using small pieces of clay or a cylinder of clay, build a simple, rectangular shape for the shaft of the nose. Blend the top of the shaft into the notch; blend the bottom into the face plane. Then, create a triangular shape for the tip (base) of the nose. Tap the top surface of the nose with the wooden block to establish the plane structure. Check the sculpture's profile against that of the model, making sure the tip of the clay nose isn't smashed against the face plane; the base of the nose should project from the face.

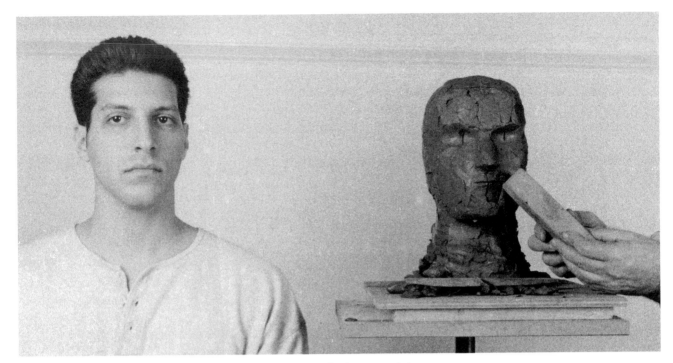

Create a v or wedge-shaped form for the nostril area at the bottom of the nose. Do this by pressing up against the clay with the bottom surface of the wood block, held at a 45-degree angle.

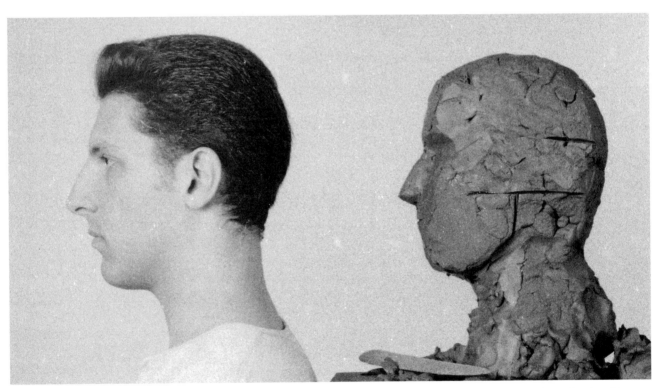

Check the angle and size of the nose in profile. The nose should look like a triangle. Make sure your clay nose doesn't grow larger then its designated size of one third of the face plane. Often, beginners will extend the nose down into the lower third of the face plane, leaving less room for the mouth; then, to compensate for not having enough room for the mouth, they'll inadvertently make the chin longer. The original proportions of the head become distorted, and the structural integrity of the form is compromised. If this sounds serious, remember that its only clay. To remedy the situation, recut the tip of the nose back to where it belongs. Simply make it smaller and move on.

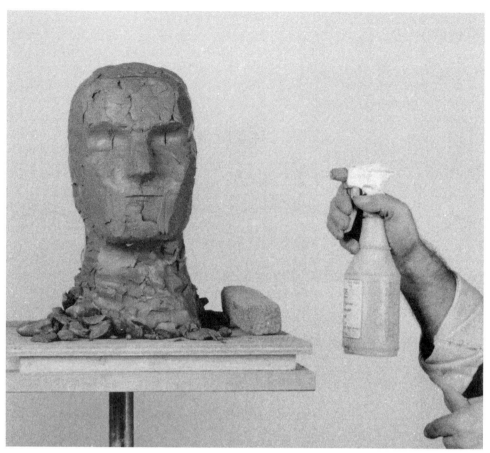

Periodically spray the sculpture with a light mist of water to keep the clay moist and workable. (Be careful not to spray your subject!)

When you want to take a break, or are finished sculpting for the day, spray your sculpture with water and wrap it with a plastic bag. Make sure the bag is airtight so that the clay stays moist from session to session.

DEVELOPING AND REFINING THE FEATURES

At this stage, the foundation of the portrait sculpture is complete. Spray your piece with water, and check it for symmetry and balance. The sides of the face should be symmetrical; the angles, size, and direction of the planes on both sides of the head should match each other. Symmetry between the left and right sides of the head is paramount.

Sculpture is the projection of form from surface. A good analogy is the topography of the earth. To get around the globe you travel in any combination of directions—east, west, north, or south—which are measured in latitude and longitude lines. You also ascend and descend in elevation for hills and valleys. Like the surface of the earth, a sculpture is a three-dimensional (art) form. To get around the shape you move from high to low, top to bottom, front to back, and side to side establishing landmarks and relationships along the way.

When sculpting, remember to observe your sculpture from as many views as possible: top to bottom, side to side, and front to back. Look up at your piece from below, and look down on it from above. Observe the live model in the same way. Observing the subject in the round (from all possible directions) is the way sculptors gather information. The more you see, the greater your knowledge of the form. The greater your knowledge of the form, the more complete your sculptural expression and interpretation of that form.

During this next stage of the sculpting process, the character and likeness of your subject will begin to evolve in your piece, and will continue to evolve as long as you develop the head in stages. Each stage consists of checking the symmetry of the sculpture, observing the model, and adding or subtracting clay. You don't make mistakes; you make adjustments.

Before putting the lips in place you first have to build the proper semicircular form of the jaw. Begin adding small pieces of clay to the lower third section of the face plane. Build the form from the tip of the nose to the bottom of the chin, and between the vertical guidelines denoting the width of the chin and mouth.

 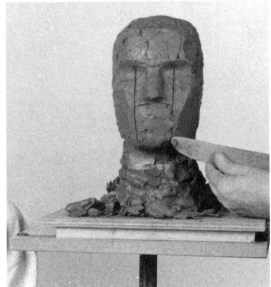

Tap the small pieces of clay with the wood block and finish developing the contour of the jaw. Check the profile to make sure you haven't changed the angle of the mouth and chin from the tip of the nose to the bottom of the chin. If the angles of your clay work don't correspond to those of your subject, your piece will lose a significant amount of the likeness and character of the subject.

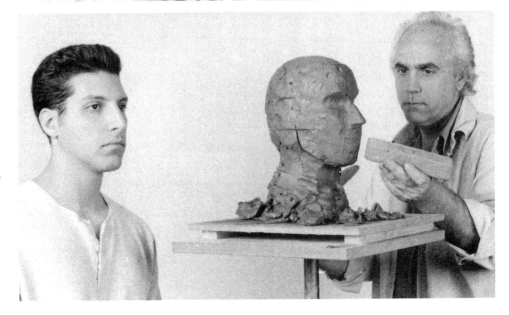

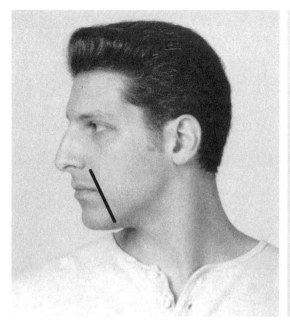

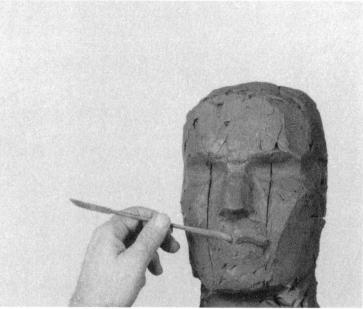

Once you've established the contour of the jaw, you can create the plane of the upper lip. Place your riffler in the center of the area in between the mouth guidelines, and angle the tool upward pressing its flat surface against the face plane. Press and slide the tool to one corner of the mouth. Then, create a depression or dimple in the corner by pulling down a quarter of an inch with the tip of the

tool. Use a sweeping, up-down-across-and-back motion to create the rhythmic curve of the upper lip. Be sure the plane of the lip travels around the contour of the jaw to the side plane of the head. Observe the subject in profile, and notice that the corner of the mouth is further back on the side plane than the spot where the back of the nostril (behind wing of the nose) meets the face plane.

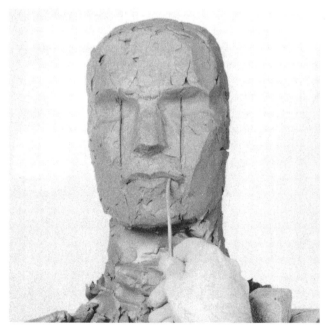

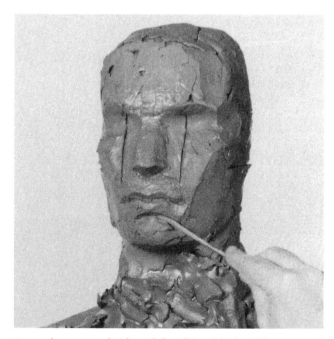

To develop the form of the bottom lip and the top plane of the chin simultaneously, hold the riffler vertically with its side to the clay. Place the tip of the tool a quarter of an inch below the top lip, and scoop out a small amount of clay. Voilà—a bottom lip! Using the tip of the riffler, held vertically, cut the corners of the bottom lip back and under the top lip in the dimple area.

Press the top and sides of the chin with the riffler to give them more shape. Remember to periodically spray the clay with water to keep it damp, as I've done here.

Create the ears with two sausage-shaped pieces of clay that are a bit larger then the nose. Place each piece on your work surface, and tap the clay lengthwise with the wood block held at a 45-degree angle. The pieces should look like wedges of orange.

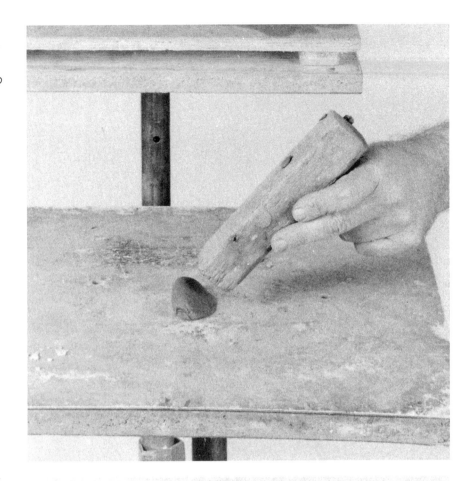

Place an ear on each side plane of the head in the center of the ear guidelines with the wedged side facing front. You should cover the x mark of the ear canal, and tilt the top of the ear back a bit.

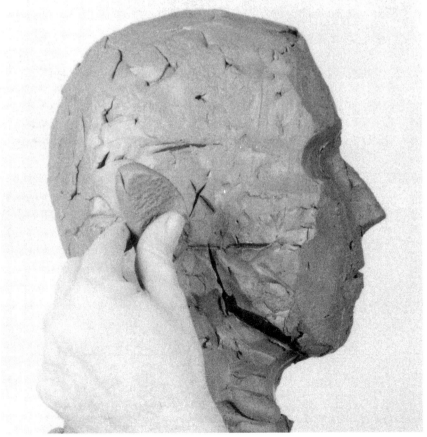

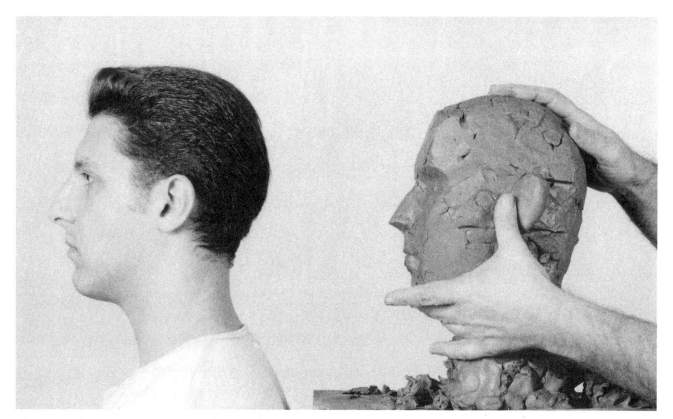

Place your thumb against the side plane of the ear, slide it from the ear to the face plane, and blend the ear to the head. Do this on both ears before moving on.

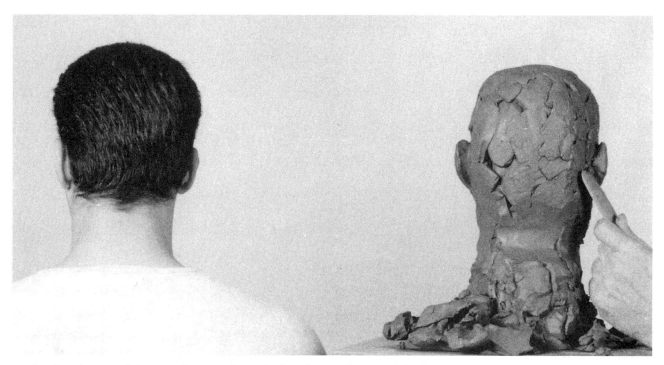

Notice that the top of the ears flare out from the head. Use the wood modeling tool or riffler to blend the back of the ears to the head. Check to see if your clay ears are the same size. Also check that they are the same distance from the front plane and the same height from the top of the head. Note that the ears aren't attached flat against the side of the head. Keep in mind the three P's: position, proportion, and planes. They're the fundamental ingredients of a successful sculpture and will help you place the features in the proper spots.

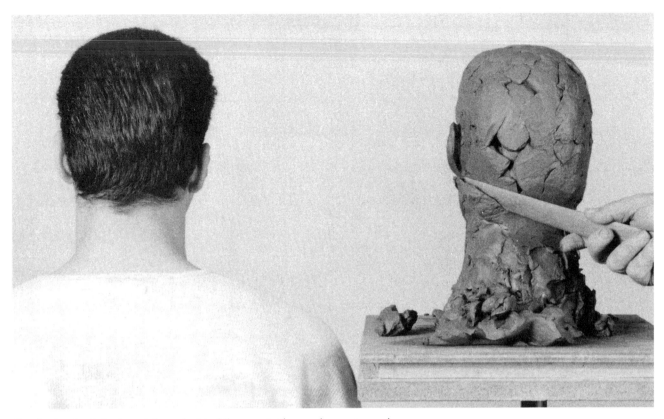

On the back of the head, from behind the ear to the neck, create a plane on a 45-degree angle to start shaping the back of the skull.

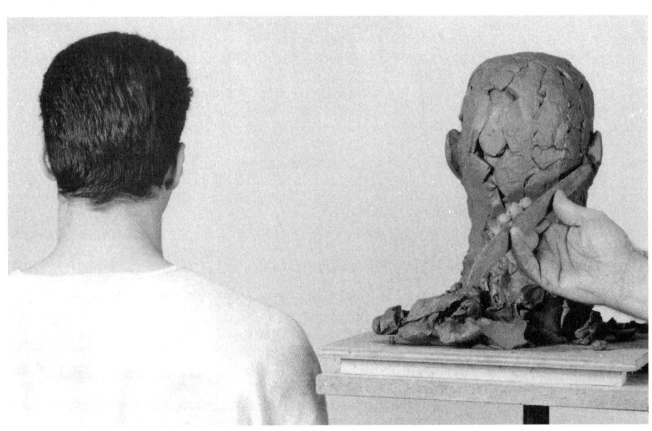

Repeat on the other side.

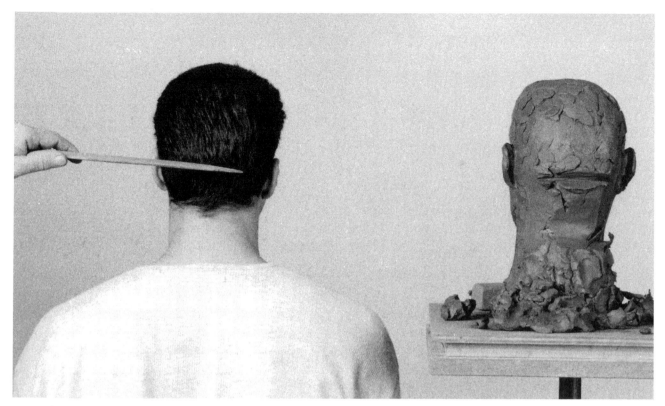

Using the wood modeling tool, mark a horizontal line in the clay (this is called scoring) in the back of the base of the skull and level with the center of the back of the ears.

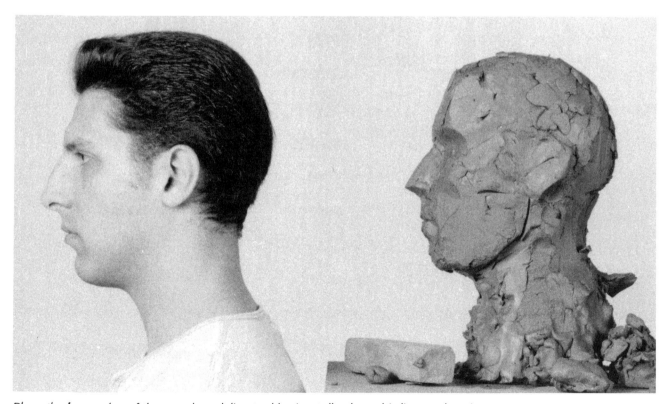

Place the long edge of the wood modeling tool horizontally along this line, and cut into the head about 1 inch. Then cut downward. Finish cutting with an outward motion, thereby creating the slope of the back of the skull and neck.

Using the rake, shape the cavities of the eye sockets. Place the rake in one socket, teeth to the clay, and pull it across the surface. Use short strokes at first. Add some pressure as you get a better feel for what the rake can do. Do the other eye socket. Both sockets are the same size and depth.

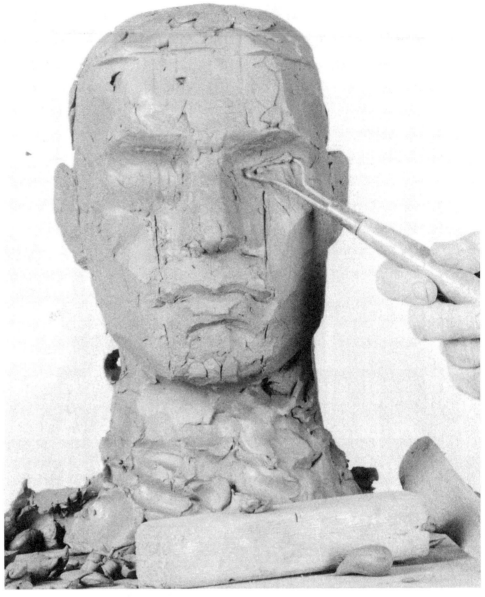

To begin forming the eyeballs, place a ball of clay half the size of the eye socket in the center of each socket. Press the ball upward with your thumb to create a disk-shaped eyeball. Don't make the eyeballs bulge out of the sockets; the eye sits deep within the eye socket, protected by the bone structure of the nose and socket. Only one quarter of the eyeball shows through the eyelid, the rest of the eye is inside the skull.

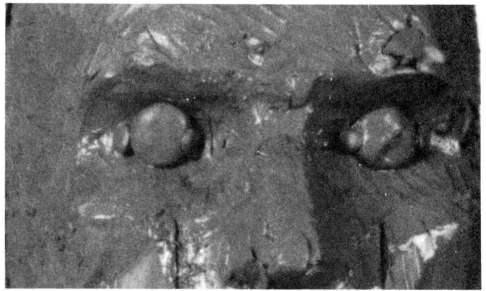

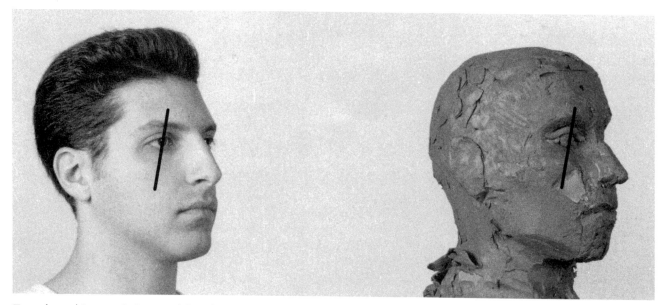

Turn the subject and clay model to the side. Notice how the top of the socket (the brow) protrudes more than the bottom (the cheekbone). Your clay eyeballs should follow the angle of this bone structure and slant back from top to bottom. Place a tiny ball of clay on each side of the larger balls. The tiny balls fill the spaces between the eyeball and the eyelids, when you add them. This will give the eyelids an almond shape.

The upper eyelids flow around the eyeballs back into the corners. Then, they come forward, out of the corners, traveling alongside the nose in a downward direction where they connect with the lower lids. The upper lid is like a rolltop desk going over the eye; it has most of the curve and shape. To form the upper eyelids, use pieces of clay that resemble string beans. Make these pieces a little longer than the eye sockets. Holding the middle of each clay string bean horizontally between your index finger and thumb, place them on top of the center of each eyeball. Press the inner corners of the lids back with your index finger. Press the outer side portion of each lid around the eyeball to the end of the socket.

The lids shouldn't extend beyond the bone structure of the sockets. Also, the outer corner of the lid is higher and further back in the socket than the inner lid. Remember that the eye follows the direction of the bone structure from top to bottom, as well as from side to side. The most difficult thing to create in sculpture is the other eye. Don't finish one eye before beginning the other. It's best to work on them simultaneously. (See page 102 for more details on how to sculpt the eyes.)

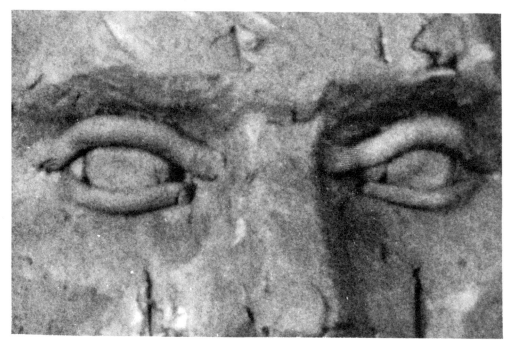

The lower lid is smaller than the upper, and holds the eye in place. It's also rounder at the outside, where it connects with the upper lid. To create the lower lids, place smaller string bean shaped pieces of clay at the bottom center of the eyeballs. Curve the eyelids around the balls and connect them to the upper lids in the corners.

Shaping and pulling the form together with the rake tool results in a better overall effect than if you try to smooth the clay with your fingers. This raking action is called *modeling*. The rake tool does to the clay what a real rake does to the soil. It evenly grades the surface of the clay, removing the lumps, and helps in shaping. Begin modeling the clay head at the side of the forehead (the temple).

Model below and above the sides of the cheeks to bring out their form. Note that the cheekbones are the landmarks of the face plane and are equidistant from the center of the nose; the distance from the left cheekbone to the left ear is the same as the distance from the right cheekbone to the right ear.

Then, model the front of the forehead. First rake in one direction, then go over the same area raking in the opposite direction; this is called cross-hatching. As you do this, apply some pressure to the rake with your index finger. Try to get a nice tight surface. Don't be concerned about tool marks on the clay at this time.

The hair grows out from the scalp on the top, sides, and back of the head, framing the face. Hair is really another feature with its own character, and it should be treated in a sculptural way, as a separate mass, and given a distinct shape and plane structure.

To start, draw a guideline for the hairline around the front of the forehead to the side of the temples and then downward, curving back and down toward the ears. Stop at the side of the ear. Complete the guideline on both sides of the head and the back of the neck. If your subject has no hair, observe the shape of the head; bald heads vary as much as faces and have plenty of character. Look for planes, high points, and contours.

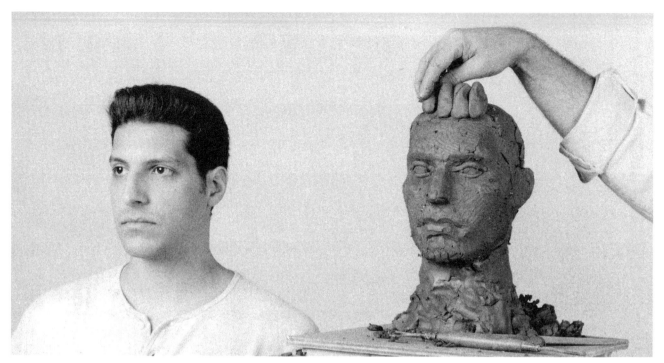

My subject, Dean, wears his hair short all around his head, with longer pieces sticking up in front. All the hair is combed back, and the longer hairs are wavy. Start forming the hair mass by placing 2-inch cylinders of clay along the hairline across the forehead. Hold the clay vertically, blending it to the top plane of the head. Curve the clay pieces toward the back of the head.

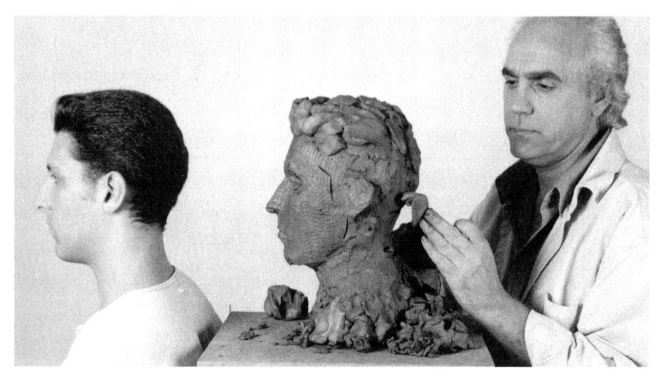

Continue building the hair mass and shaping the head by adding more cylinders of clay and some smaller pellets of clay. Use the wood modeling tool to add and pat down the clay. Loosen up and have some fun with the hair; vary the size of the clay pieces. There's not too much detail, and you can explore different textures.

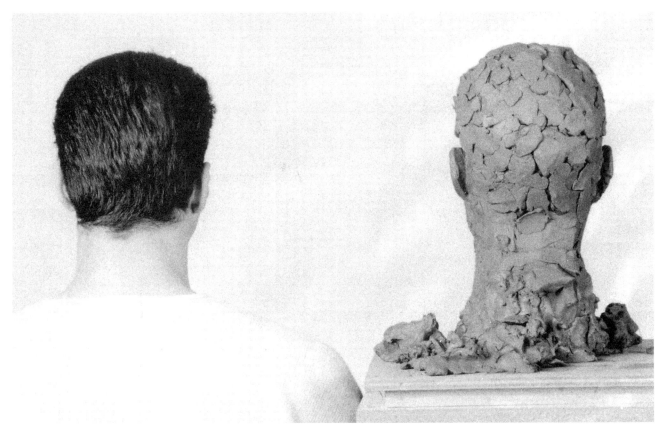

Don't forget to sculpt the back of the head and hair.

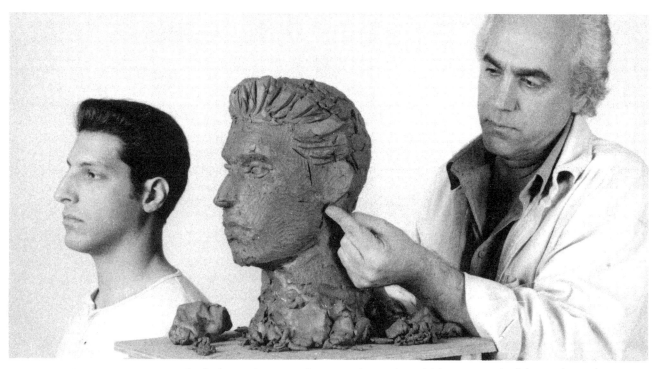

It's essential to continue viewing both the sculpture and the model from all angles. Here, a comparison of the two revealed a need for more clay around the earlobe.

The ear has an outer rim, which travels from the inner canal upward and around the outside to the lobe, and an inner rim, which starts at the lobe and travels up to the top of the ear where it splits in two under the outer rim. The tragus and antitragus are the smaller lobes above the large ear lobe. You should check the position of all these elements.

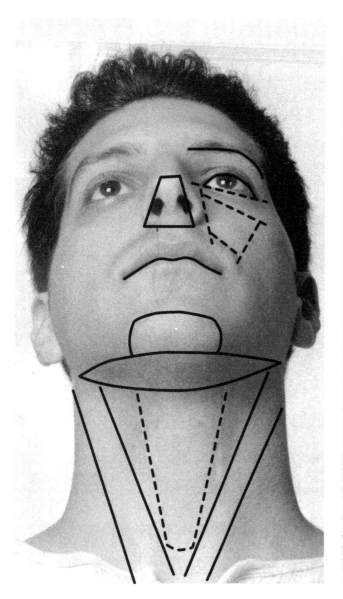

Have the subject tilt his or her head back, and observe the head from below. Note the contour of the forehead. The brow follows this contour and curves from the front plane to the side. Also, the outside corners of the eye sockets are further back on the face plane than the inside corners. The eyes follow the direction and angle of the sockets, slanting from inner corner to outer corner. The surface of the face plane below the eyes and alongside the nose slants in the same direction as the brow, from the side of the nose to the cheekbone.

The underside of the nose forms a triangle, the three angles of which are created by the tip and the two nostril wings of the nose. The contour of the mouth follows the curve of the jaw. The mouth blends into the cheeks. Note how the corners of the lips don't stick up off the face plane. The lower lip fits tightly under the top one.

The chin is a separate form, block-shaped with rounded corners. The shadow between the neck and chin is the plane formed by the bottom of the jaw and the chin. The tubular-shaped sternocleidomastoid muscles of the neck start at the skull behind the ear and connect to the collarbone at the pit of the neck.

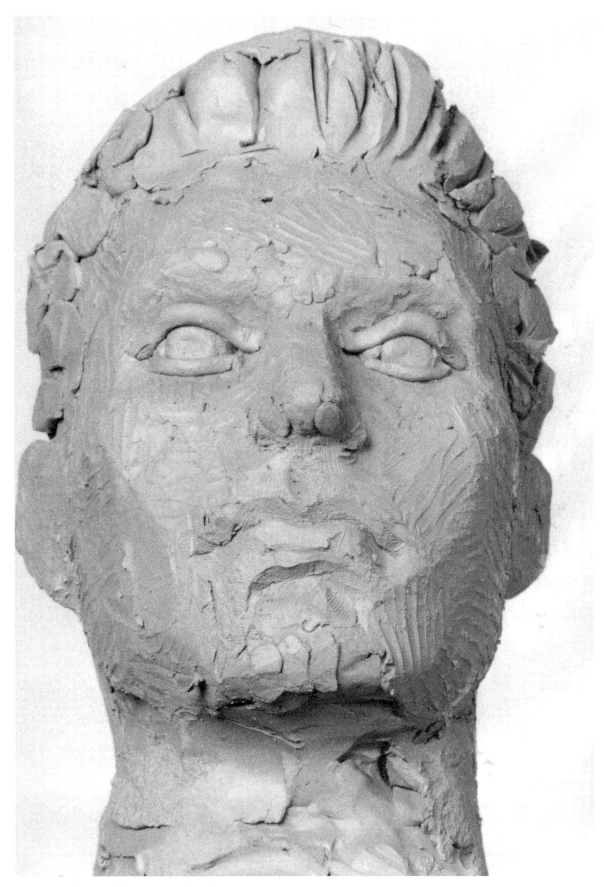

Compare the model to your sculpted version.

 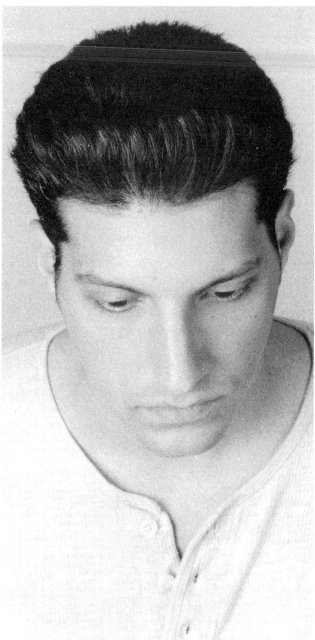

Now have your subject tilt his or her head down. Observe the direction and contour of the brow from this angle. It begins at the top of the nose and, like the forward edge of the wing of an eagle in flight, it gracefully curves back to the end of the eye socket. The thin edge of the upper eyelid echoes the rhythmic flow of the arching brow above it. The outside edge of the nostril, from the tip of the nose to the back of the nostril, repeats the same line. This undulation appears again on the top edge of the upper lip. It dances along from the center of the mouth to its corner, where it mysteriously fades into a dimple. The composition of line, rhythms, shapes, and planes on the human head are unique to this subject.

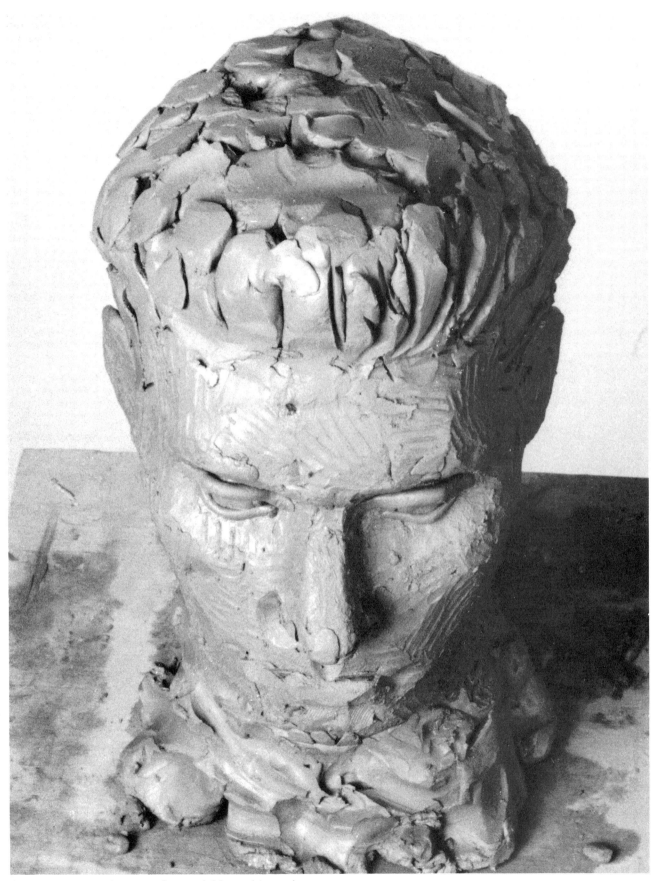

Compare your sculpture to the model from this angle.

The final finishing stage of development requires very close observation of the smaller and subtler forms and shapes of the face.

Now is a good time to take a break, relax and chat with your model, before continuing to sculpt.

At this point, we're about halfway through. All that's left is the refining of the features and the application of the final surface texturing. Here, I refine the area above and around the mouth (where the mustache grows on men). It's convex, and in young people, it's framed by fine creases that start in the hollow space behind the nostril and continue past the outer corner of the mouth (see highlight on photo). In older people, these creases are more like folds or, more euphemistically, "character" lines.

Observe this area closely. Determine whether it forms a gentle flowing transition to the cheek, or a deep abrupt separation from the back of the nostril. In this instance, I'm creating a shallow transition using a scooping motion of the wood modeling tool. Draw a guideline here, with the modeling tool, if your model has a deep fold.

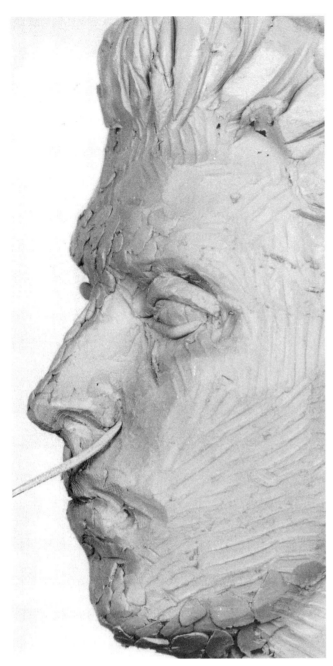

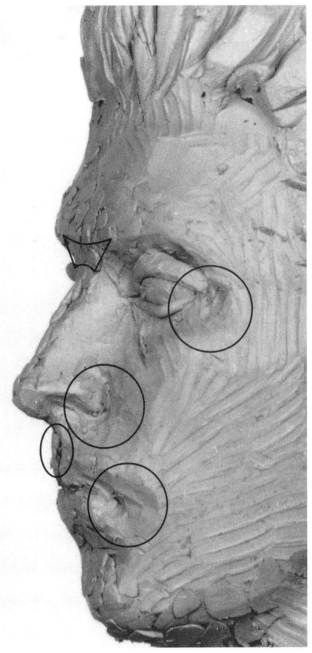

There's a fascinating transitional spot where the wing of the nostril meets the face plane. Two hilly surfaces of the face plane converge in this little valley: the top convex form of the mouth and the surface of the cheek next to the nose. To bring this area to life and form the back of the nostril, place the end of your riffler above and behind the wing of the nostril on the face plane. Roll the riffler back against the face plane, and pull the tool down and under the wing in a semicircular motion, removing clay from the face plane. This one motion accomplishes three tasks; it creates the back form of the nostril wing, it forms the area behind the wing, and it defines the more subtle transition between the cheek and the mouth next to the wing. Do this on both sides of the face.

Scoop some clay from below the nose to create the insides of the nostrils. Don't gouge large holes. Also press behind the nostril with the riffler to create the rounded shape of the back of the nostril wing. Refine the indentations below the nose leading to the mouth, around the outer corners of the eye sockets and the mouth, and in the notch between the browline and nose, as well. All these areas are circled in the photo.

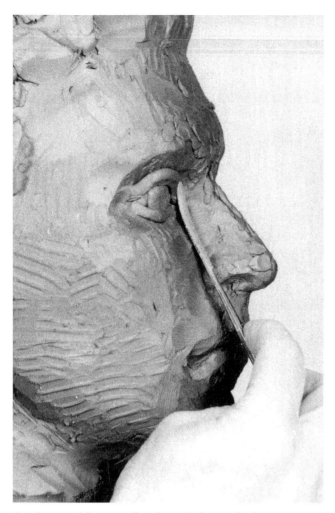

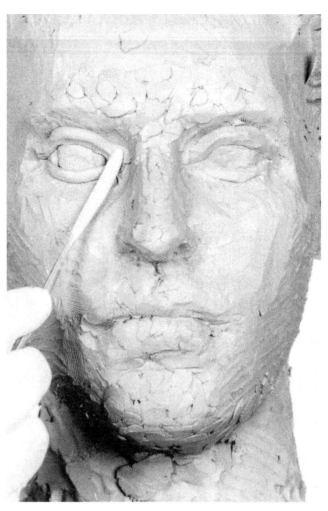

I've been adding small pellets of clay to the brow, nose, and chin as needed. There are also a few other subtle transition areas that are evident on the face plane and to which you should pay attention: first, the dimple in the corner of the mouth; second, the outside corner of the eye socket on the face plane; and third, the philtrum, the vertical space bordered by thin ridges located above the center of the top lip. All these transitions are significant. They help define bone and flesh. Also, check the angle and depth of the notch, or glabella, where the nose meets the forehead and the angle of the philtrum from top to bottom in profile.

Start refining the eyelids using the riffler. Make sure the eyeballs slant back from top to bottom following the bone structure (see top photo on page 71). Create a front and bottom plane for each lid by pressing the riffler against the top and bottom surfaces of the lids and making a sharp edge between the surfaces to define the change of plane. To maximize the benefits of the riffler as a modeling tool, lift the tool slightly off the surface and then press down, repeating this motion while moving the tool along any given surface. Done quickly, this should be a tapping motion. Press gently when sculpting details.

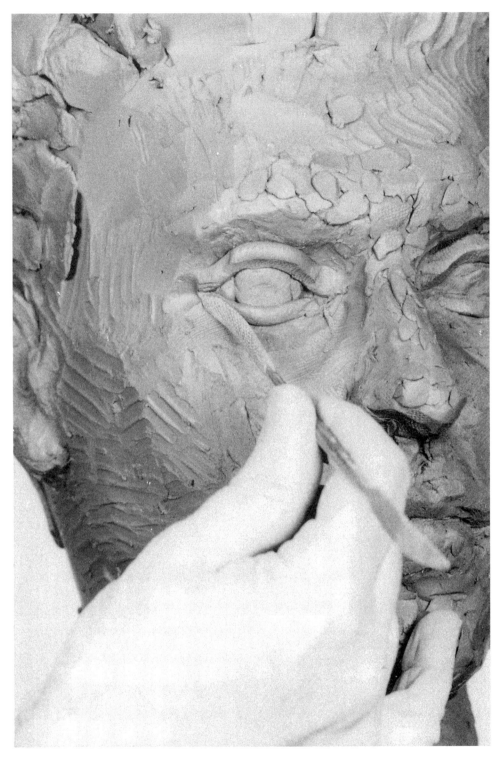

Press the corner of the upper eyelids back with the riffler. Use the riffler to contour the lower eyelid around the eyeball and then create a small plane next to the eyelid on top of the cheekbone. Press the tool down on the face plane and pull across the top of the cheekbone. Slide the tool forward and down alongside the nose to complete the eyelids.

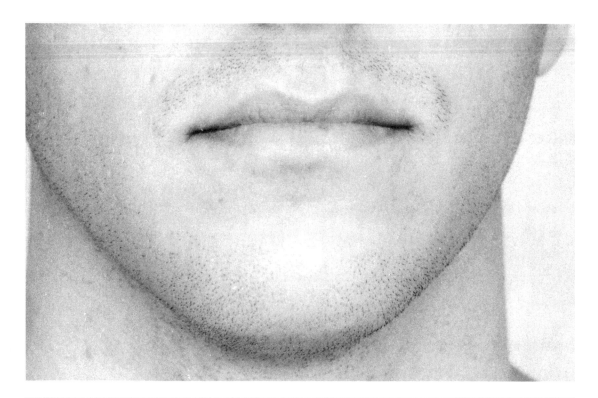

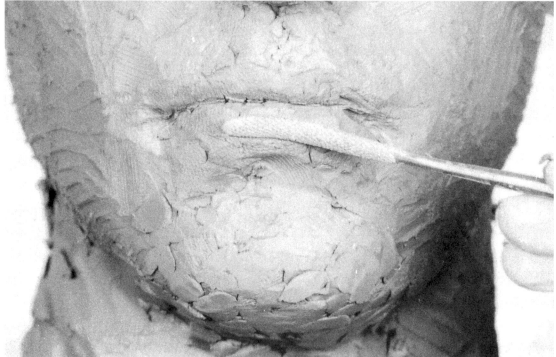

Adding small pieces of clay to the lower and upper lips and the chin gives more volume to these features. To create the fine ridge around the lips press the edge of your riffler along the outside contour of the lips and roll it, following the shape of the mouth.

The upper lip has three forms or muscles—a round one in the center and an oval on each side. On the model here, the center form is not pronounced or obvious. The lower lip only has two oval forms—one on each side with a flat surface in between. When the mouth is closed, the forms interlock perfectly to create a curving seam.

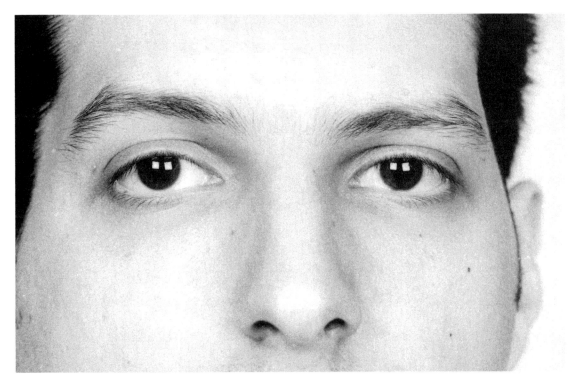

Draw circles for the irises, and blend the surfaces of the eyeballs and lids where they meet. There are no spaces between the eyelids and the eyeballs. Round out the eyeballs in the corners, and shape the inside corners of the eyelids that pull away from the eyeballs at the inside corners of the eye sockets.

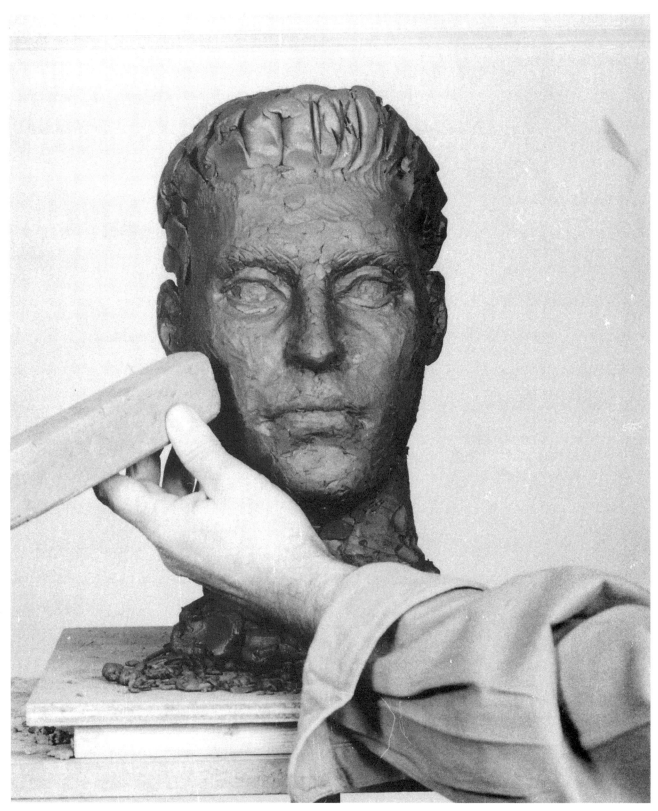

Continue to shape the head by gently tapping the bone structure with the wood block. Tap around the cheekbones, forehead, chin, and jaw, following the contours of your subject.

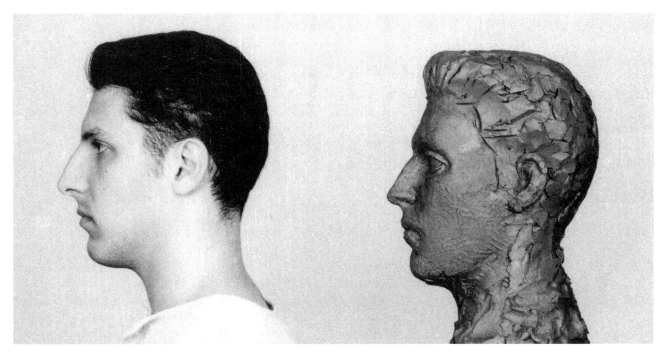

Check the profile of your piece, comparing it to the model. First, follow the contour of the head, beginning with the forehead, around the brow, into the glabella (notch), across the top of the nose, around the ball of the nose, into the philtrum, up and over the lips, and around the chin. Then, continue along the jawline up to and around the back of the ear. There's a great deal of movement along the surface of the form even though the model is sitting still.

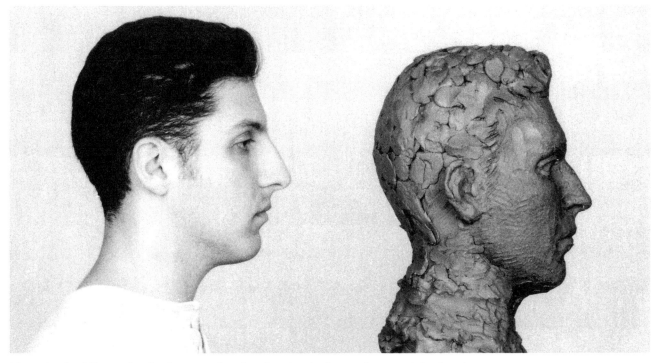

Now check while moving in the opposite direction, beginning at the top of the head and going down around the back of the skull into the large trapezius muscle in the back of the neck. Note that the neck leans forward as it extends from the upper body. The front and back of the neck should be parallel. Model the neck with the rake if necessary. Also, remember to walk around your sculpture and check it from both sides.

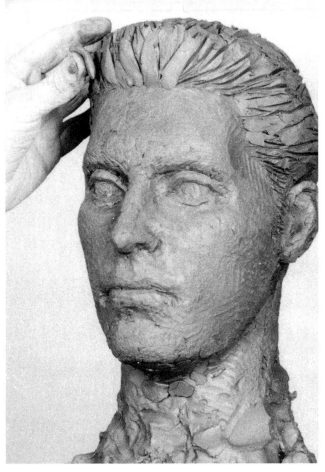

Next, work on the hair mass. Dig the small edge of your wood block into the hair at the hairline in the front and sides of the head. Press and pull back with the block, following the direction of the hair.

Continue to build and shape the hair mass with small pieces of clay, particularly at the hairline.

To achieve a subtle, uniform surface texture on your piece, first spray the sculpture with water, and then hold your piece of burlap bunched up and begin blotting or tapping the entire surface of the sculpture with it. Watch the contours and forms come to life. Nothing is carved in stone; create the texture as rough or smooth as you like. Texture is like a signature; it adds distinction.

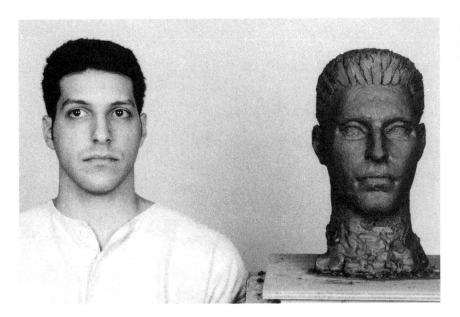

Now that you're near completion, it's a good time to set your sculpture as close to the model as possible to compare the two.

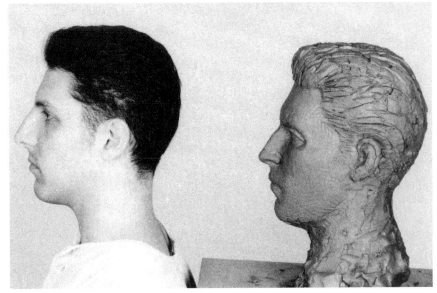

Continue to look from all angles for areas that need adjusting.

Don't forget to check the back view of your sculpture, also comparing it to the back of the model.

Check the symmetry of your piece from below before executing the final detailing and texturing.

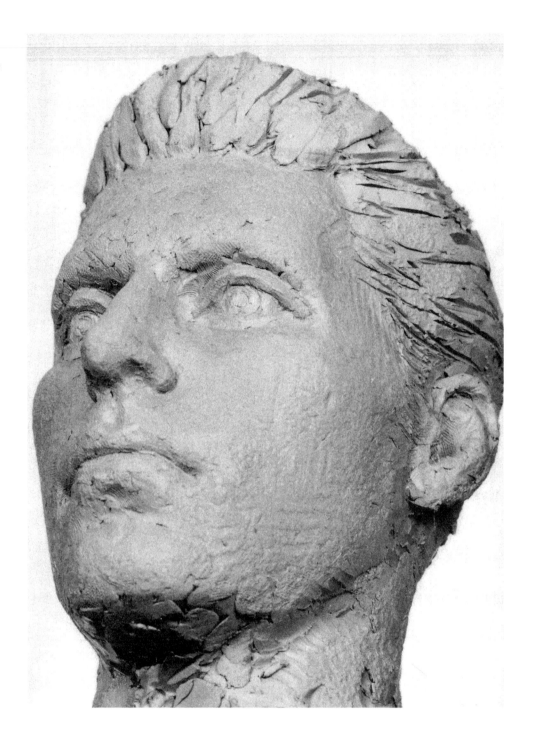

Note that you can also execute the final details and textures of your portrait later on, from photographs of the model if you have them.

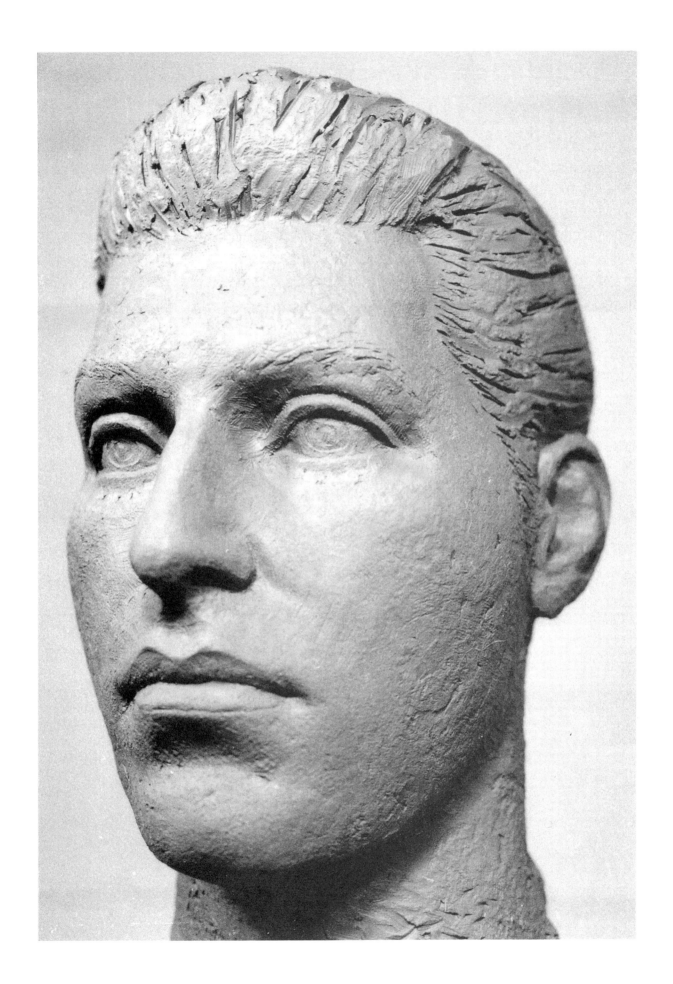

THE INDIVIDUAL FEATURES

This chapter provides in-depth demonstrations of how to sculpt each of the specific facial features, beginning with the fundamental plane structures and moving on to the finished forms. I've intentionally sculpted basic, generic features so that you can focus on how to create each feature without worrying about capturing the likeness of a model. You can use this chapter to supplement the previous one, and if you are practicing along with me, I suggest that you build up a head mass first, and draw placement guidelines, as previously discussed, for the features before beginning them.

THE NOSE

There is no correct order in which to sculpt the individual facial features; you can begin with any one you like. I start with the nose. The nose is triangular in shape. There's a flat plane along the top from the bridge (brow) to the base (the tip of the nose). The sides of the nose slope out from the top plane down to the cheeks.

The tip of the nose is triangular when viewed from below, and it projects forward from the face plane. In profile, the nose also appears as a triangle. The base of the nose has three distinct forms—the ball at the tip and one "wing" on each side of this ball forming the nostrils. Look at your subject's nose carefully before beginning.

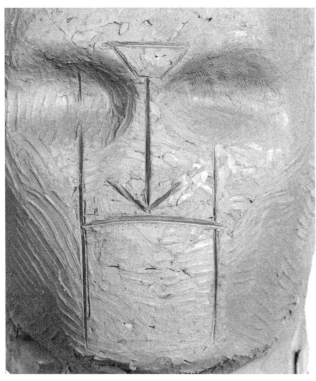

To begin, draw a nose guideline in the center third of the face plane using the wood modeling tool. Draw a v at the bottom of the line. Also draw an upside down trapezoid shape for the glabella between the eyes, from the brow to the nose. Then draw a line from the center of each eye socket down to the end of the face; these will be the guidelines for the corners of the mouth.

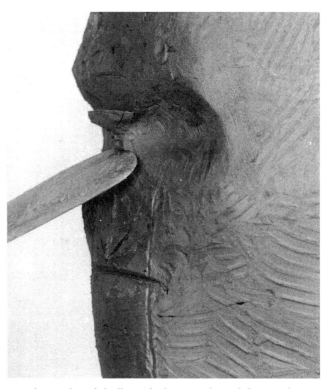

Notch out the glabella with the wood modeling tool.

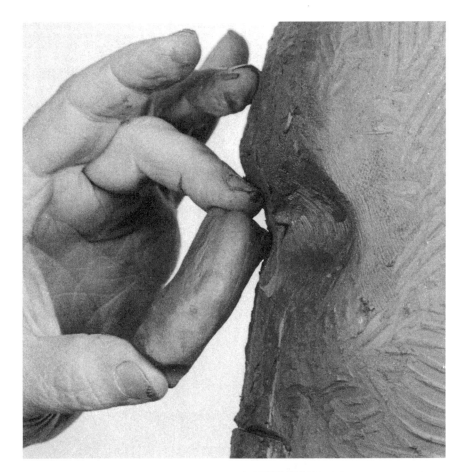

Roll a cylinder of clay the length of the nose guideline.

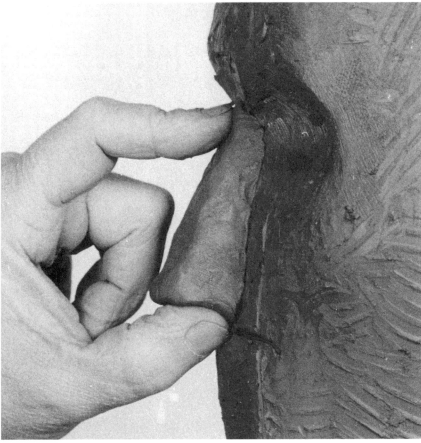

Press and blend the top of the nose cylinder into the notch. Use your thumb to guide and blend the bottom of the nose to the face. Note that the nose is a triangle from the side view.

Using the riffler, blend the sides of the nose to the face. Shape the base (or tip) of the nose into a triangle.

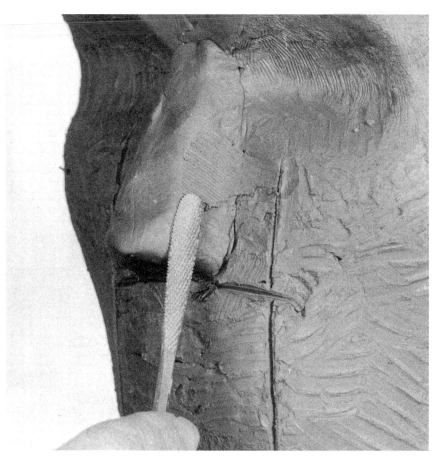

Tap the top of the nose with the wood block, creating a flat plane.

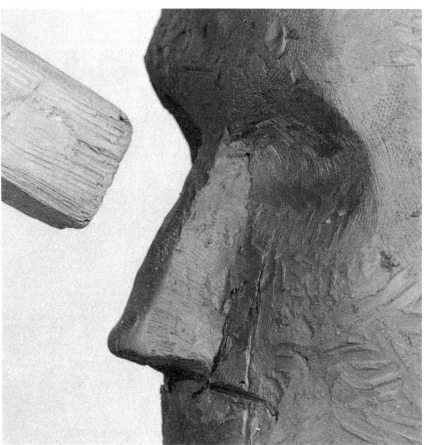

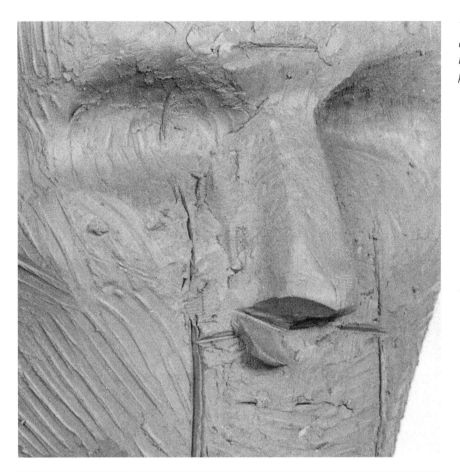

To form the flare of the nostrils, cut angled planes at the bottom of the nose from the tip back to the face plane.

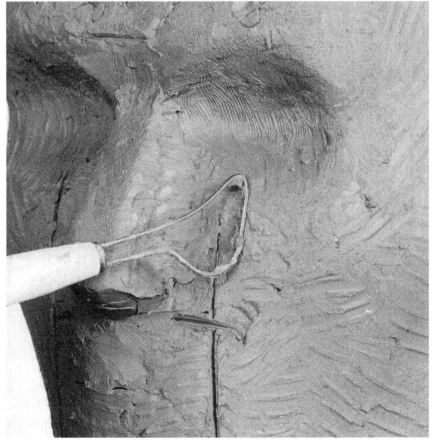

Create a flowing surface from each cheek to the side of the nose with the rake.

You should develop the structure of the nose before moving on to sculpt the details.

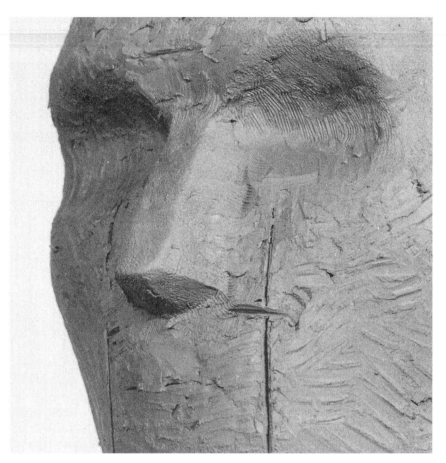

The wings of the nose (the top back forms of the nostrils) are shaped like balls. To model them, place your riffler at the top of each wing, and with a twisting-backward-and-downward motion, scoop the clay from behind the wing.

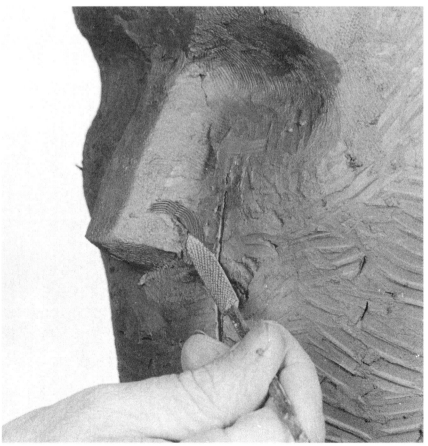

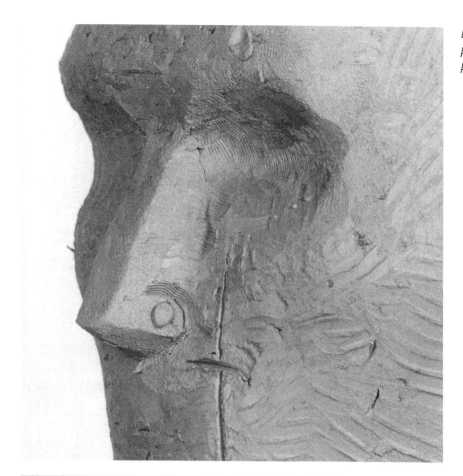

Build up the shape of the wings by placing a ball of clay on the side plane of each nostril.

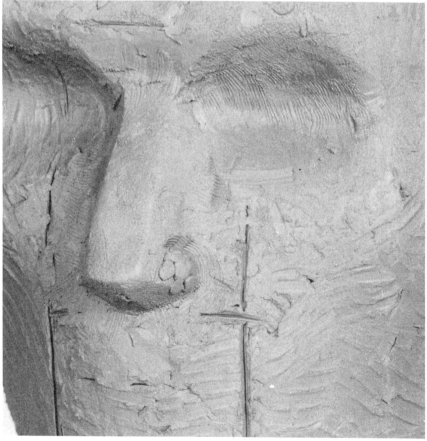

Add smaller pellets of clay, and tap with the wood block. Continue to shape and tap with the riffler.

Draw guidelines to form the ball-shaped tip of the nose.

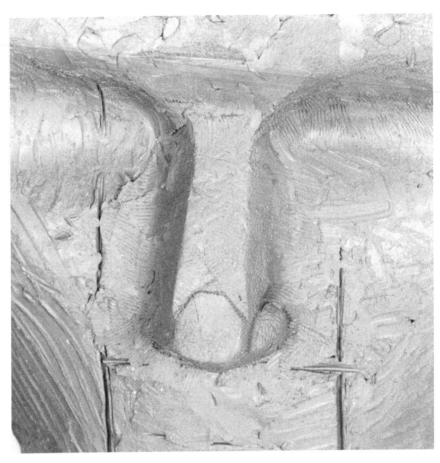

Build up the tip of the nose with small pellets of clay.

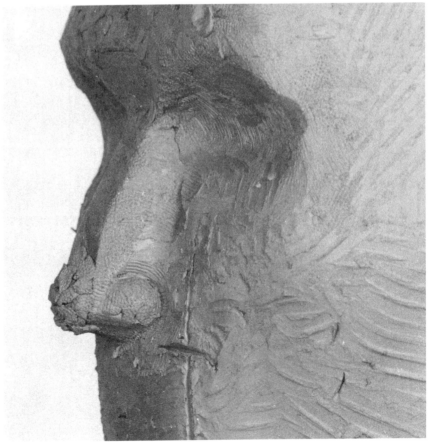

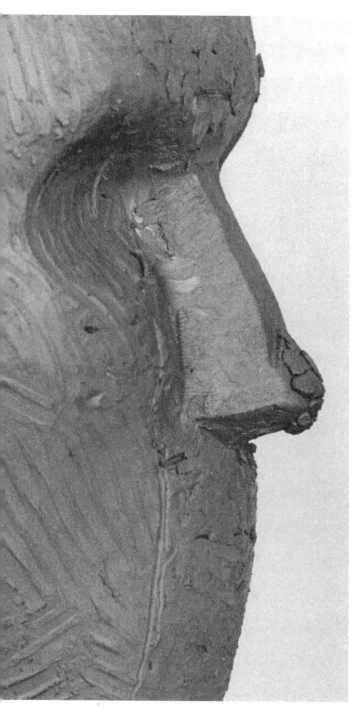

Build up the ball shape underneath the tip of the nose, as well.

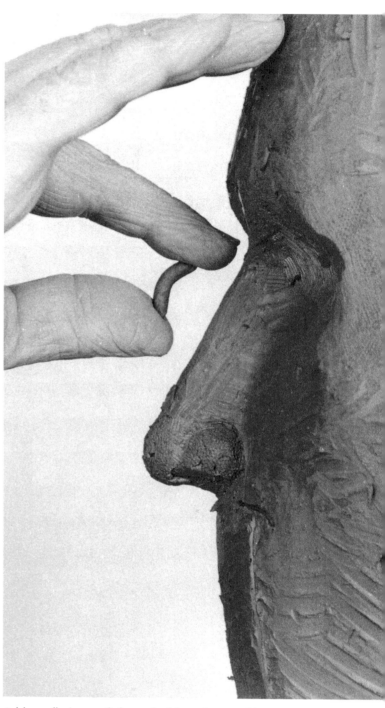

Add small pieces of clay to build up the nasal bone in the center of the nose.

The finished profile view.

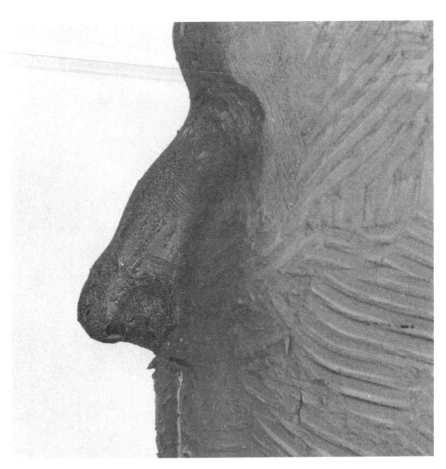

Create the nostril openings on the wedged plane on the base, or bottom side, of the nose using the riffler to scoop clay out sideways. Don't dig deep holes.

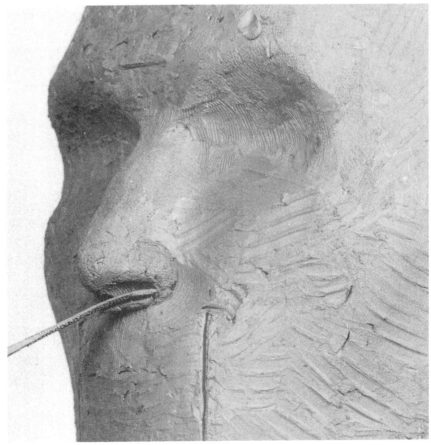

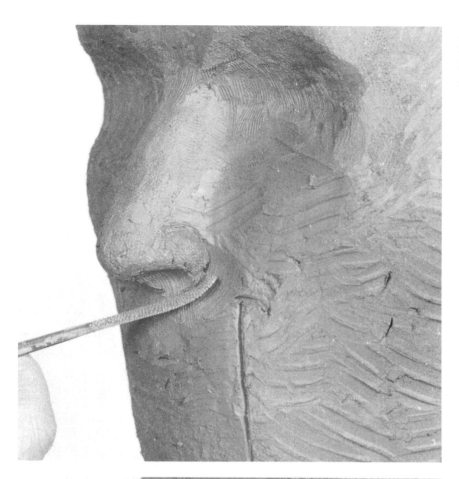

Shape the back of the wings and transition areas behind the wings on the face plane. Press and roll your riffler behind the wings.

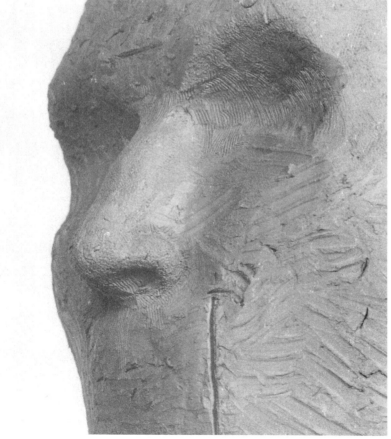

The finished nose.

THE EYES

The eyes are equidistant from the bridge (top) of the nose. They fit snugly in the center of the eye sockets, and they also follow the direction of the bony socket structure, which slants slightly from the front to the side of the face. The eye sockets should be large and deep enough to accommodate the size of the eyeballs and eyelids. The eyeballs don't normally protrude beyond the bone structure of the sockets.

Most of the eyeball is set inside the skull. The top lid is like a rolltop desk. When it opens, less than half of the eye is visible. On it's front surface, the eyeball has a dark, round pupil set in the iris (the colored part of the eye). When sculpting, avoid making dots or pinholes for the pupils; this tends to give the eyes an artificial expression.

Place a ball of clay in the center of each eye socket.

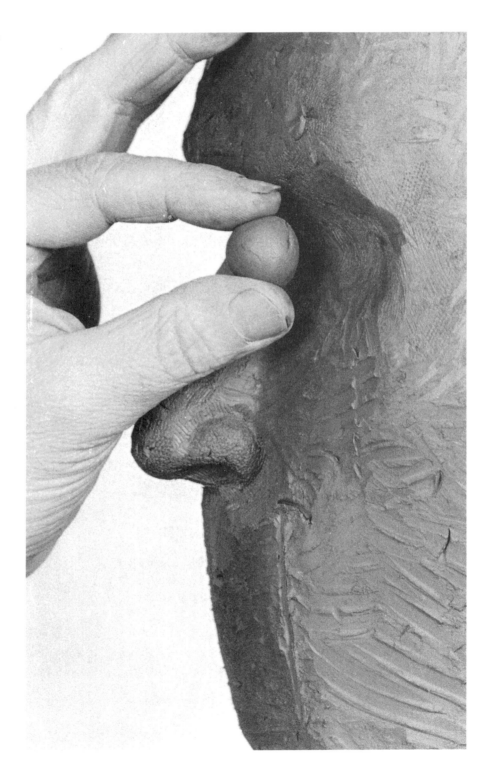

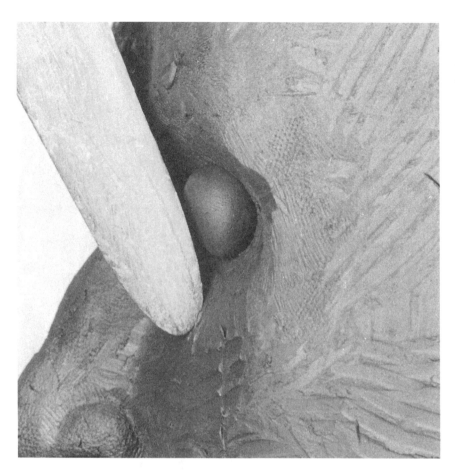

Note that the sockets slope back, from top to bottom, when observed in profile, and the eyeballs should slope in this same direction. Also, notice how the brow protrudes beyond the cheek.

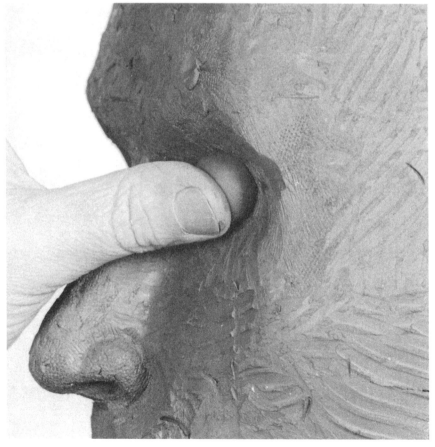

Give the eyeballs direction. Press each ball up into the sockets holding your thumb at an angle. The eyeballs should now have a flat surface in front.

Add small balls of clay to each side of each eyeball.

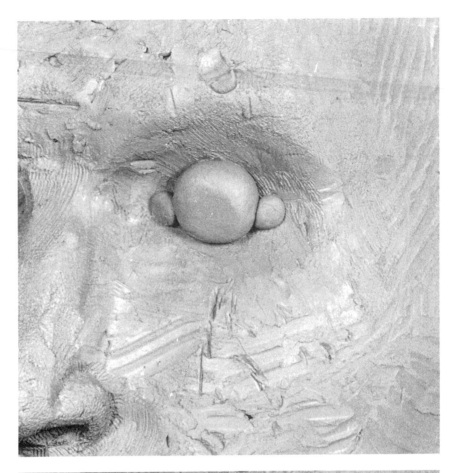

Roll a piece of clay slightly longer than the socket for each upper eyelid. Place the center of each lid piece to the center of the eyeball, leaving space between the lid and brow.

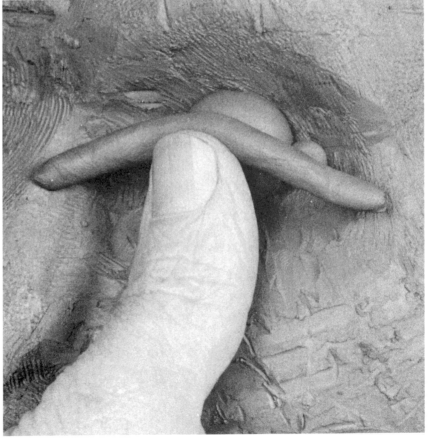

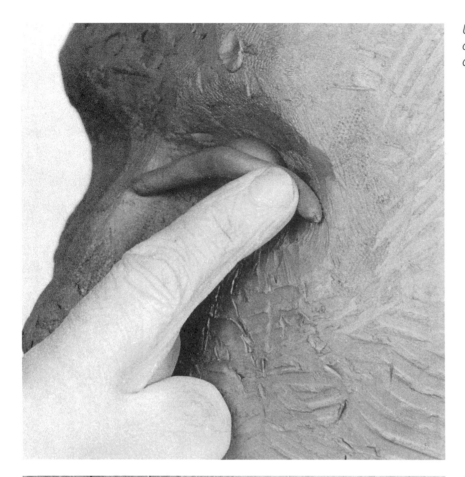

Using your finger, press the lids around the eyeballs into the outside corners of the sockets.

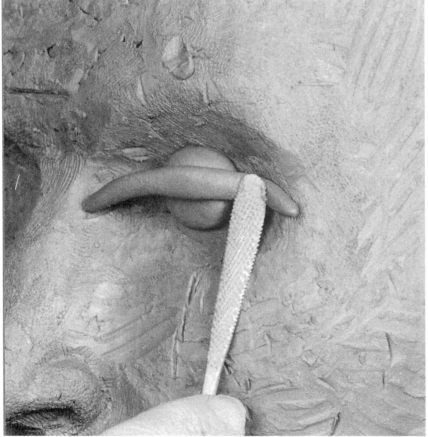

You can also use the riffler to do this.

Again, using your finger, press the lids around the eyeballs into the inside corners of the sockets.

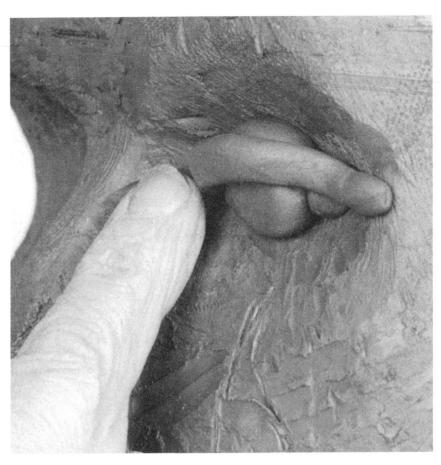

You can also use the riffler to do this.

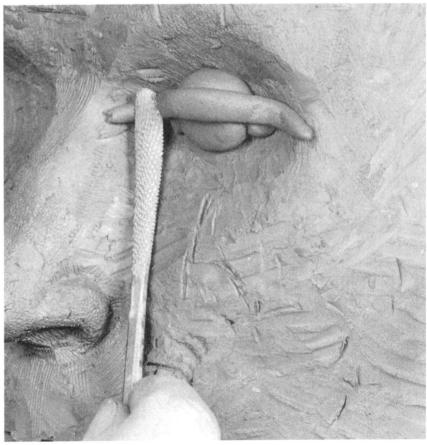

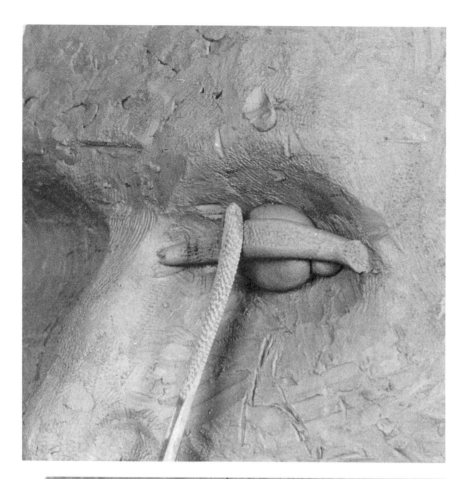

Place the riffler on the upper lid, where it begins to turn around the eyeball into the inside corner.

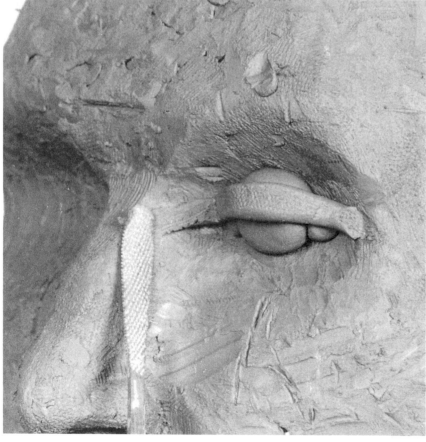

Slide the riffler along the surface of the lid into the corner. Then, turn the tool and slide back out alongside of the nose in one rhythmic motion. Remove the excess clay. Trim the lid at the outside corner. The lid fits inside the socket. Repeat on the other side.

*Use smaller pieces of clay for the
lower lids.*

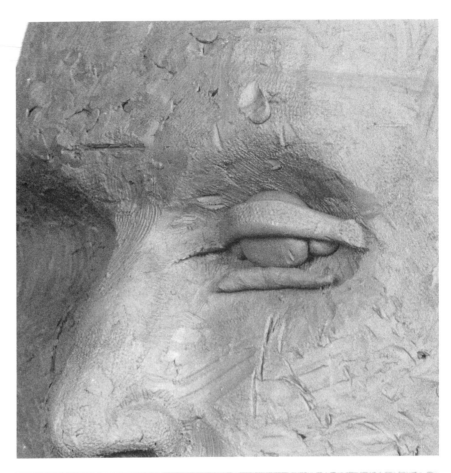

*Curve the lower lids around the
eyeballs to the outside corners,
and tuck them under the upper
lids, pressing with the riffler.*

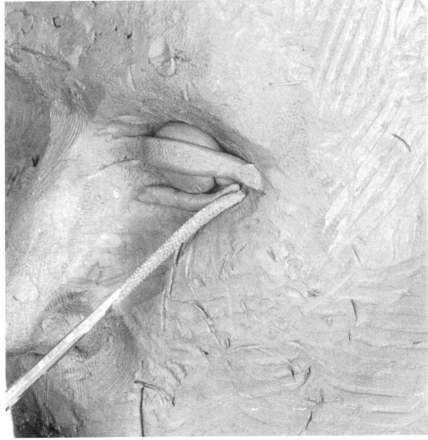

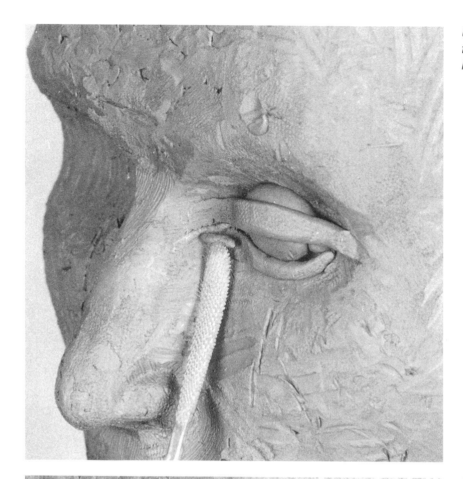

Use small pieces of clay to connect the lower lids to the upper lids in the inner corners of the sockets.

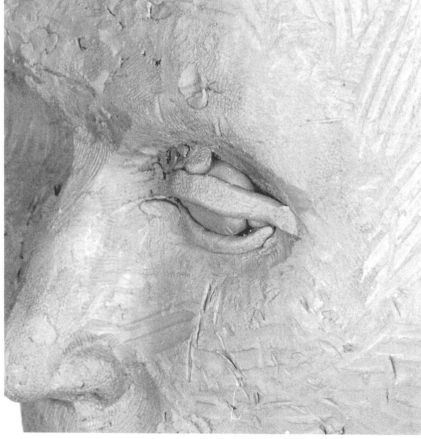

Build the fullness of the upper lids, adding small pieces of clay to the top of the upper lids between the lid and the brow.

Place the riffler on the bottom plane of the upper lid, near the inside corner, and press up.

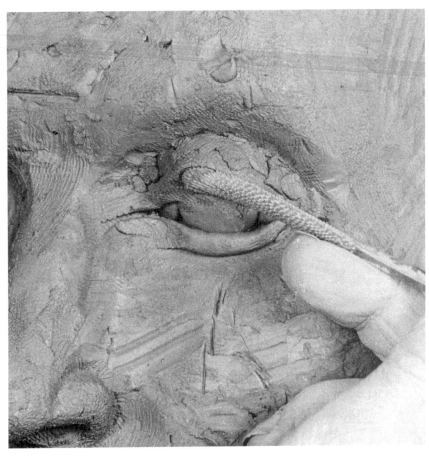

Doing this will give more shape and contour to the lid.

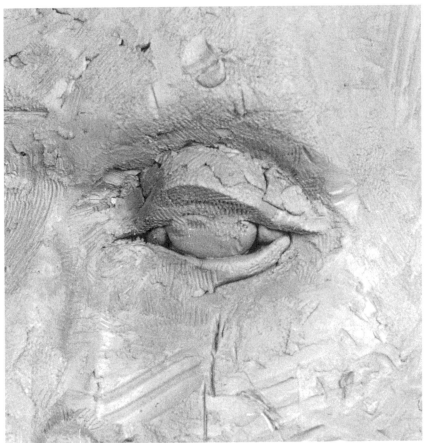

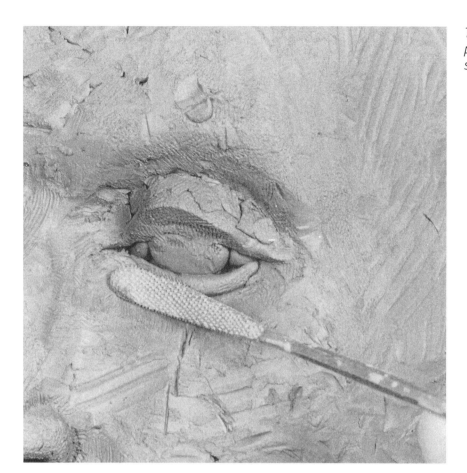

To blend the bottom lid into the face plane, place the riffler on the lid and slide it down.

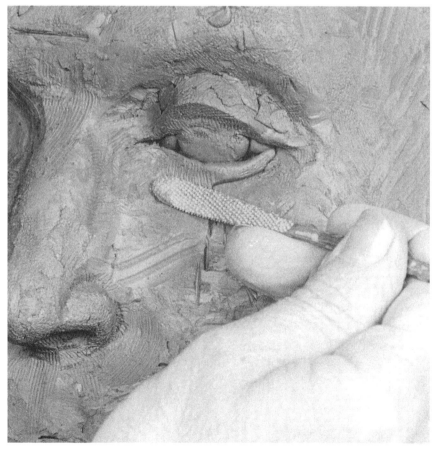

Smooth the lower lid into the upper cheek.

Note that the lids come together and form a point at the inside corner. This point pulls down and away from the eyeball. To sculpt this, place your riffler in the corner of the eye, and press and roll the tool to round out the eyeball in the inside corner.

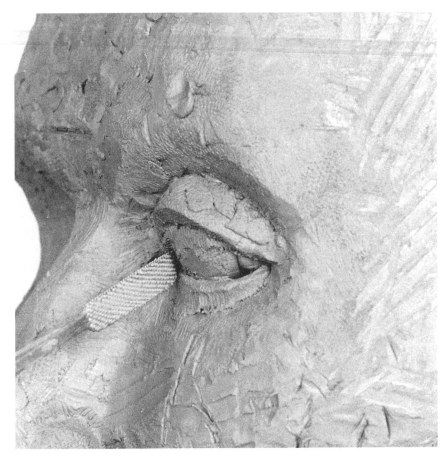

Fill the space between the eyeballs and the lids with small pellets of clay.

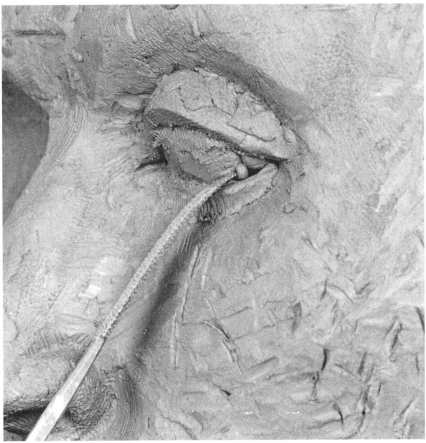

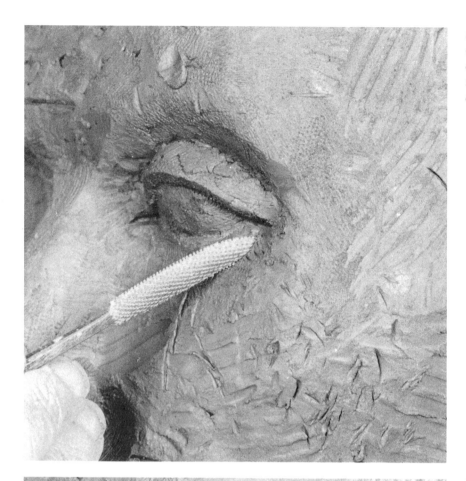

Holding the riffler on the outside corner of the eyelid and pressing down, establish the bone structure of the lower socket on the outside corner next to the lower lid.

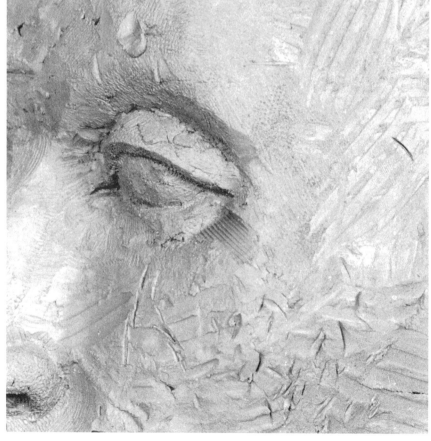

Slide the riffler to the outside, and remove the clay.

To form the bone structure of the lower socket on the inside, below the lower lid, place the riffler on the face plane between the nose and the lower lid and press down, twisting the tool toward the lid. Create a shallow groove.

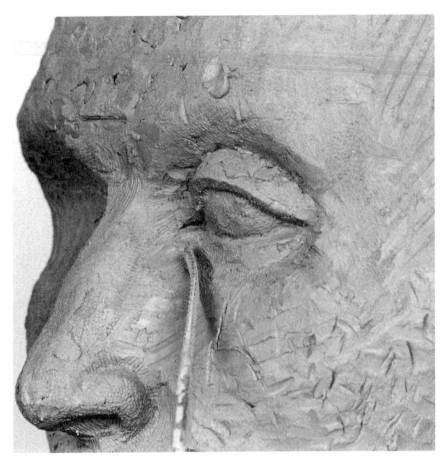

The finished eyelids.

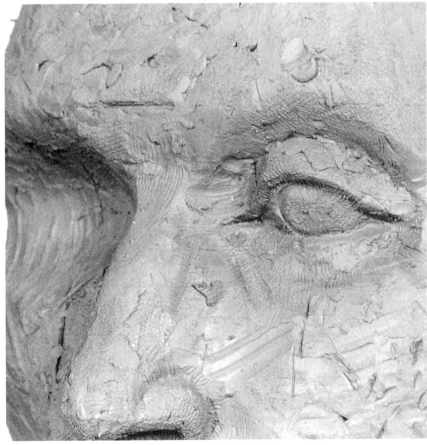

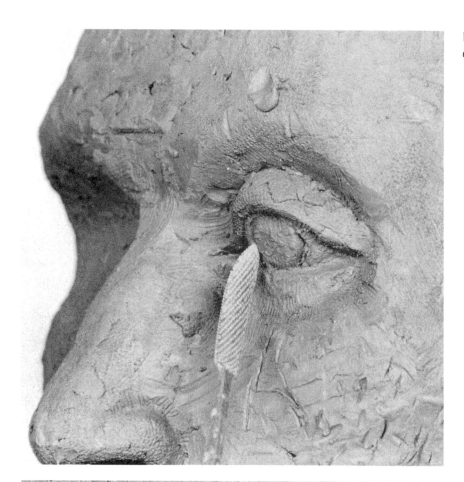

With the riffler, draw a circle on each eyeball for the iris.

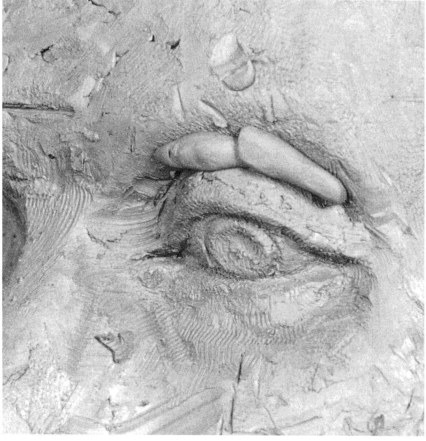

Depress the surface of the eyeball inside each iris with the rounded side of the riffler to create the pupil. The treatment of eyes varies among sculptors, depending on the desired expression. Sculpting only the eyelids, without eyeballs, also works. Try it both ways or somewhere in between. Just remember the most difficult thing in sculpture is to sculpt the other eye, so work on both eyes simultaneously.

Build up the form of the brow above the upper eyelids.

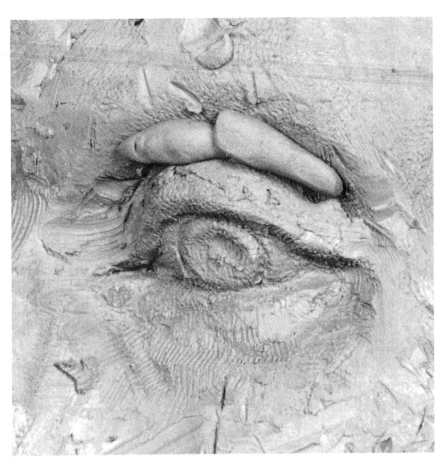

Build up more form for the eyeballs, where they push out below the lower lids.

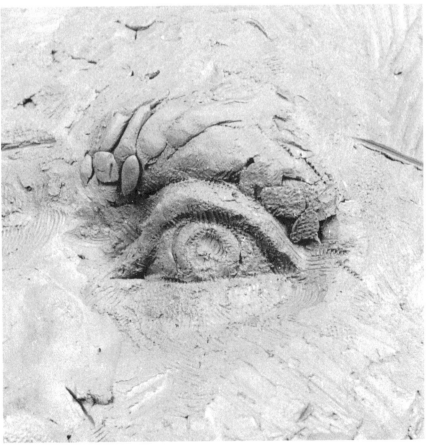

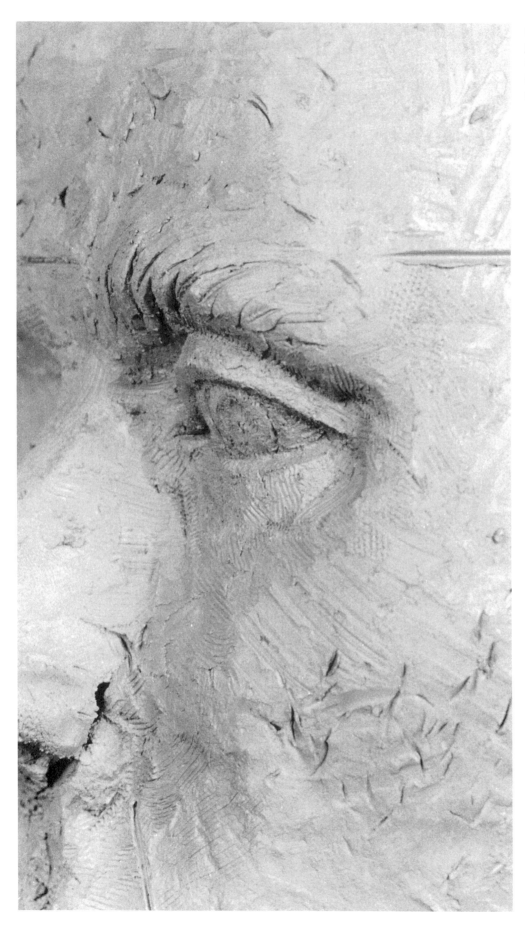

Finally, add small pieces of clay to the eyebrow. Incise small lines with the riffler to create eyebrow hair.

THE EARS

There are two basic elements to the ears: the outer rim (or helix) and the inner rim (or antihelix). The outer rim begins inside the concha (the large concavity of the external ear, also know as the canal), continues up around the top and flows to the bottom into the earlobe. The inner rim helps form the concha; it begins under the outer rim at the top of the ear, splits, and curves out and down alongside the outer rim. The inner rim flows into the antitragus and tragus above the earlobe. Note that the ears are located at the same place on opposite sides of the head, and that they don't lie flat against the head but flare out from the skull.

For each ear, roll a coil (a cylindrical piece) of clay the size of the nose. Tap the clay with the wood block, holding the block on an angle. Create a wedge-shaped form, like a piece of orange, with a flat plane on each side.

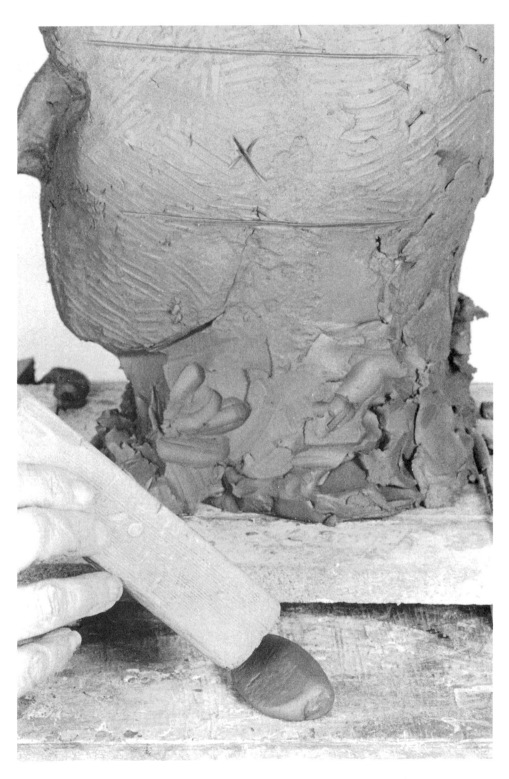

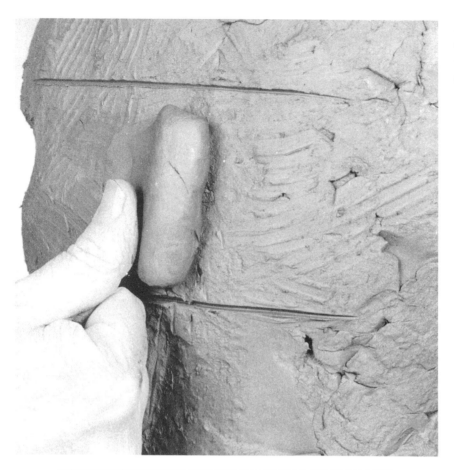

Place the ears, thin side facing front, over the x marks in the center of each side plane of the head. When positioning the ear, tilt the top of the ear back toward the rear of the skull. Blend the front plane of the ear to the head using your thumb.

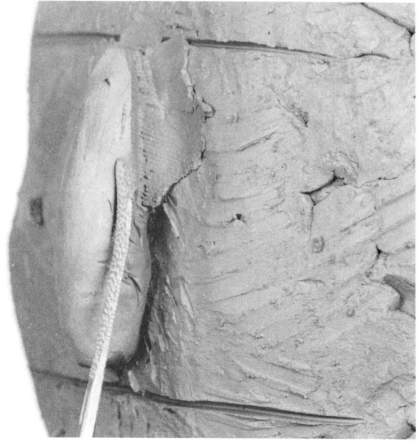

Blend the back plane of the ears to the head using the riffler.

Cut and shape the top of each ear.

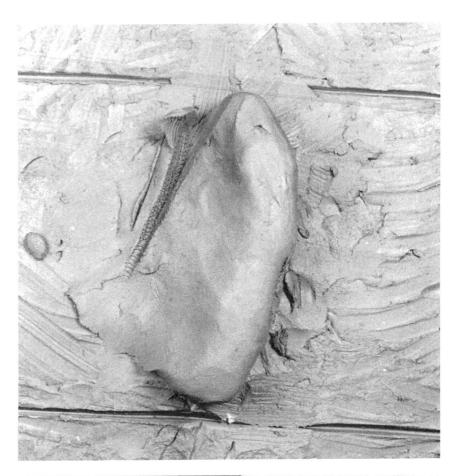

Draw a line on the front plane of each ear, two thirds of the way down from the top of the outer rim to the earlobe.

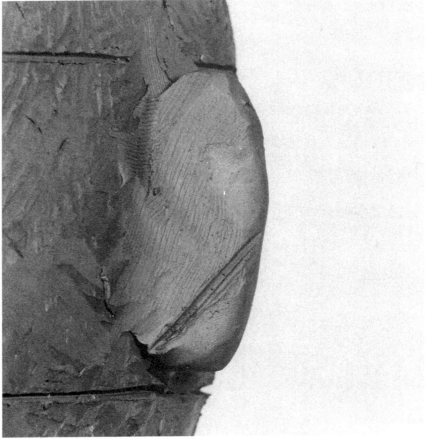

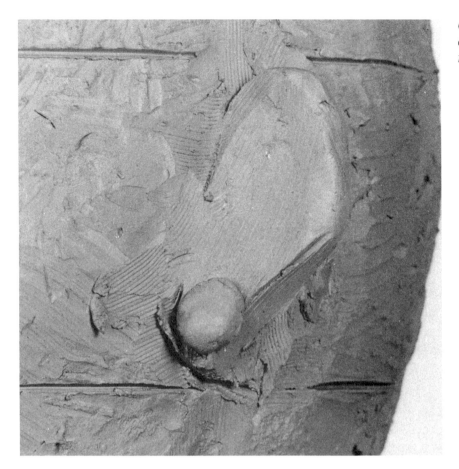

Cut and shape the lower portion of each ear. Add a ball of clay to each for the earlobes.

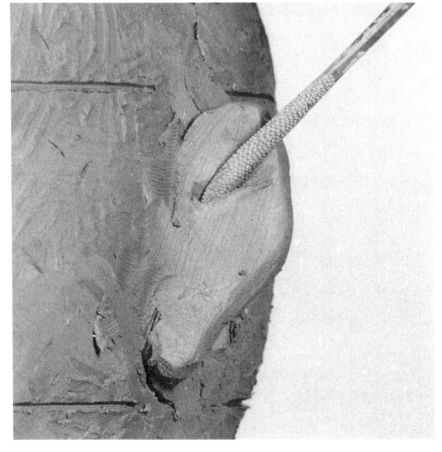

To make the ear canals, place your riffler on the plane of the ear near the top. Tilt the tool back, and scoop down and forward. Remove the clay.

The ear canal should fall toward the front of the ear wedge.

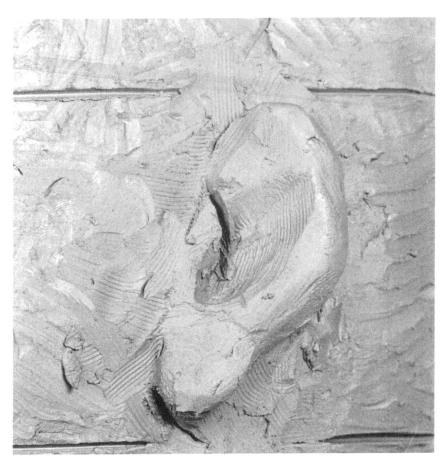

Check the angle and position of both ears from the back view.

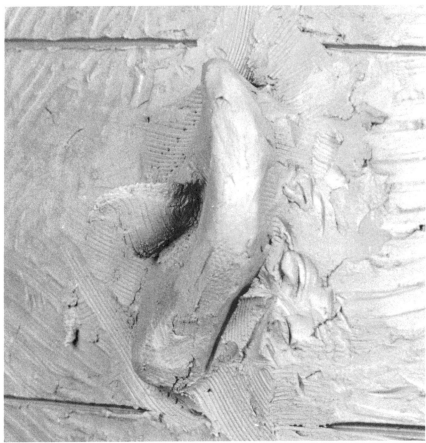

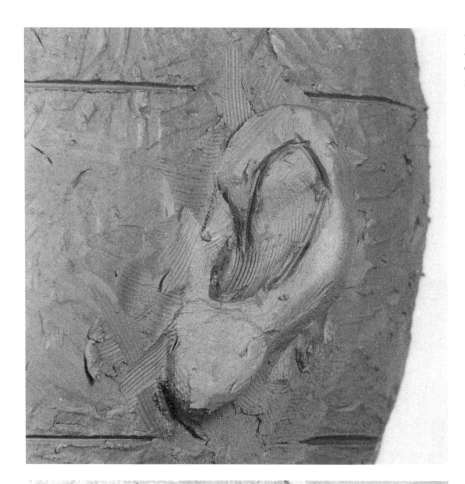

On both ears, draw the outer rim from inside the center of the ear, around the top, and down the side to the earlobe.

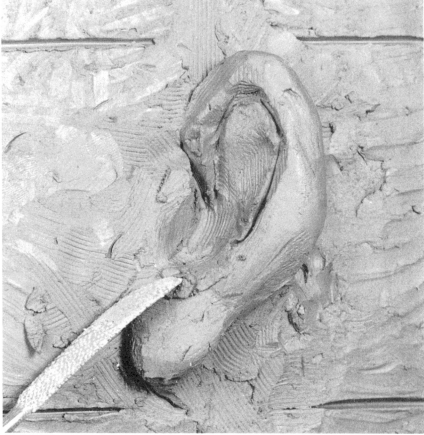

Build up the small lobe of the antitragus, located above the earlobe. Also, build up the form of the tragus, located at the side of the head just above, and connected to, the antitragus.

Next, create the small transition area between the earlobe and the antitragus on both ears. Begin developing the inner rim.

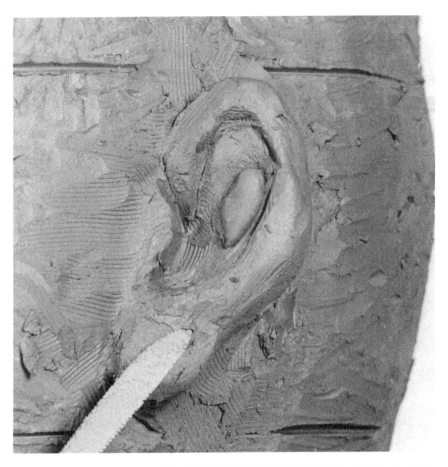

Draw a small v at the top of the inner rim of both ears.

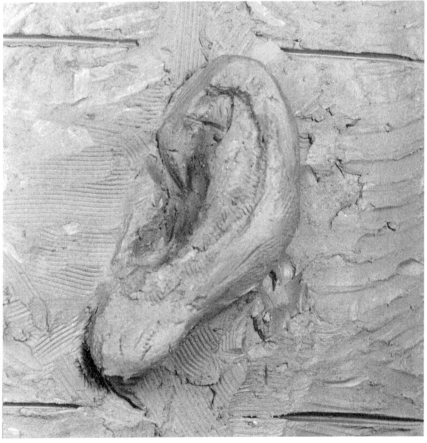

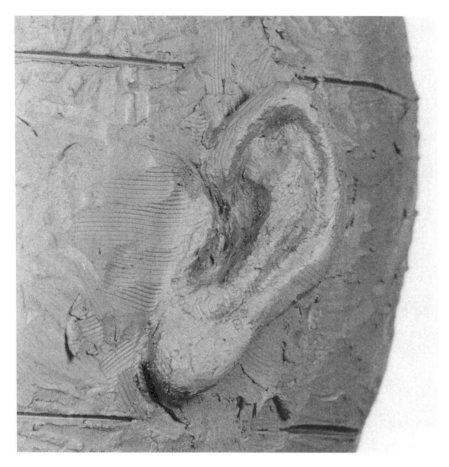

The inner rim splits into two directions at the top and fades under the outer rim. Carve out the v to create this split of the inner rim.

Observe the curvature of both ears from behind.

Also observe the curvature of both ears from the side.

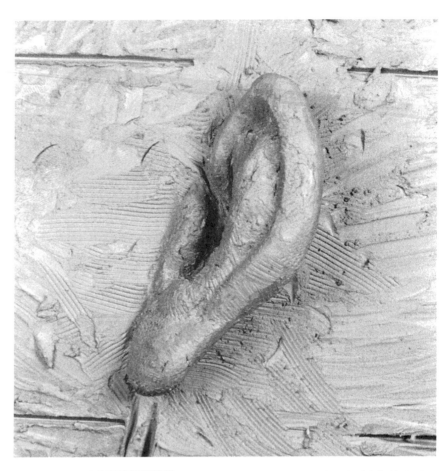

And finally, observe the curvature of both ears from the front. Remember: The ears don't sit flat against the head.

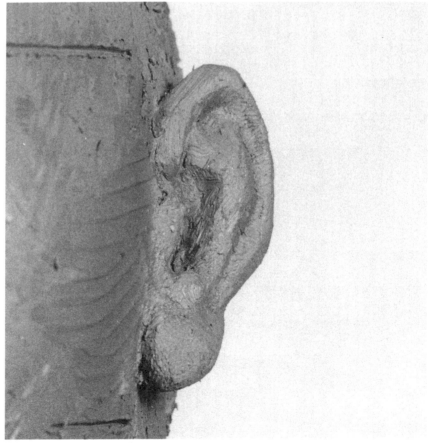

THE MOUTH AND CHIN

Internally, the mouth contains the teeth, tongue, and palate, and the lips form the exterior of the mouth. The upper jaw (maxilla), the lower jaw (mandible), and the chin (the lower part of the mandible) form a semicircle shape for the lips to rest against. To position the lips accurately on this curved plane, I suggest that you draw guidelines first to delineate the width of the lips and the chin. The length of this section runs from the bottom of the nose to the bottom of the chin. The mouth and the chin are as wide as the distance between the centers of the eyes.

The chin is a block shape that projects slightly from the front of the bottom jaw. The front plane of the chin slopes back from the top to the bottom; it either recedes from, protrudes beyond, or is even with the lips when the face is observed in profile.

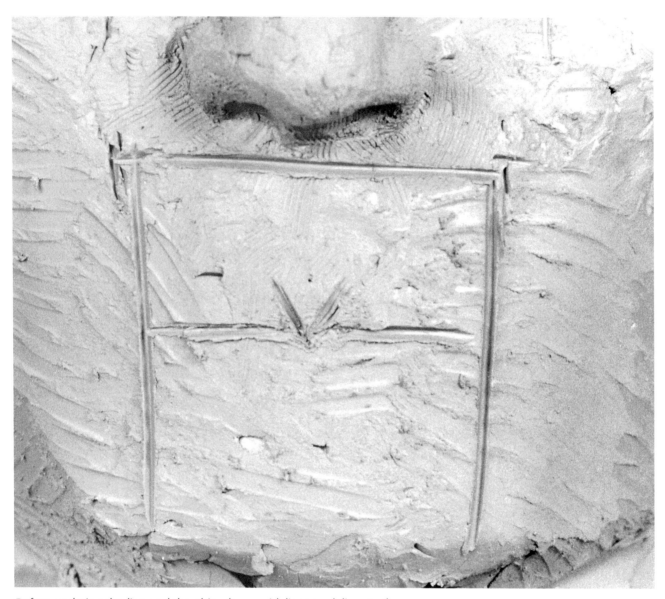

Before sculpting the lips and the chin, draw guidelines to delineate the semicircular section of the jaw where the mouth and chin will be. Draw the lines indicating the height of this section horizontally under the nose and at the bottom of the chin (if you feel it's necessary). These lines should intersect with vertical lines, which you draw down from the center of the eyes to indicate the width of the mouth and chin. Draw a horizontal line in the center of this section where the lips will go, and add a v in the midpoint of this line to emphasize the central form of the top lip.

To delineate the plane of the upper lip, place your riffler at one side of the v and slide it from the center to the outer corner of the mouth. Push in with the tool, pull down a third of an inch, and remove the clay to create a dimple in the corner, as in the photo below.

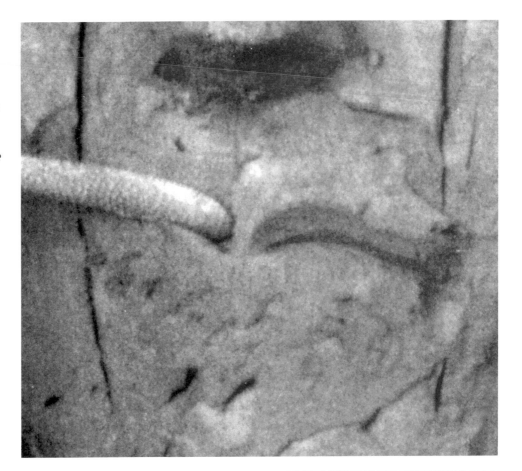

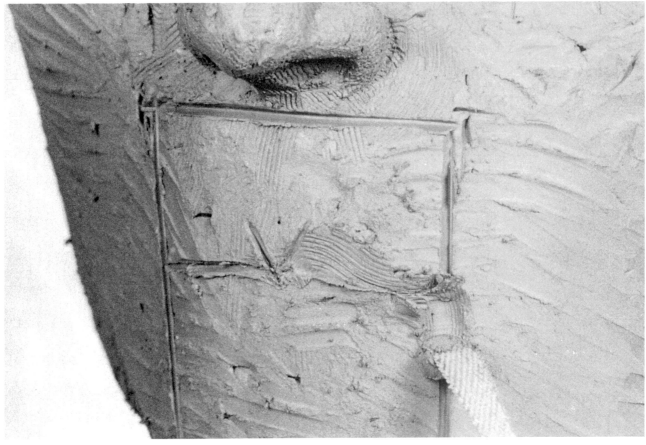

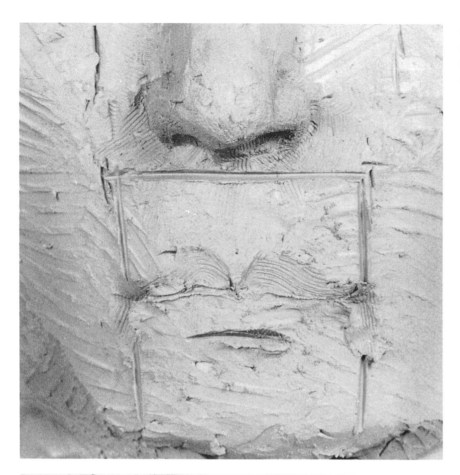

Repeat on the other side, and also draw a horizontal line a third of an inch down from the center (horizontal) guideline.

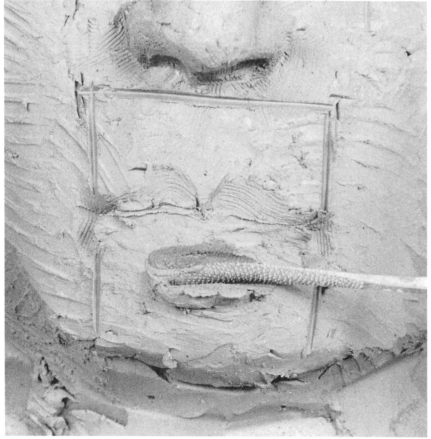

Create the form of the bottom lip and the top plane of the chin by scooping some clay out at this spot.

To establish the top plane of the lower lip, place the riffler at the center guideline; press down and roll the tool forward to form the plane.

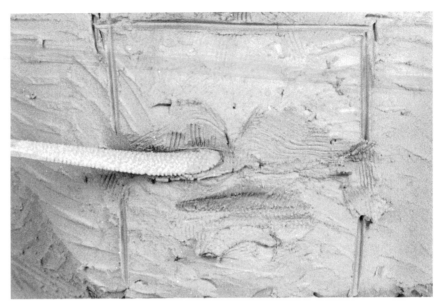

Cut the outside corner of the lower lip back into the dimple under the upper lip.

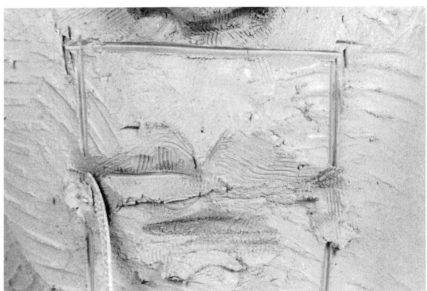

Repeat on the other side of the mouth.

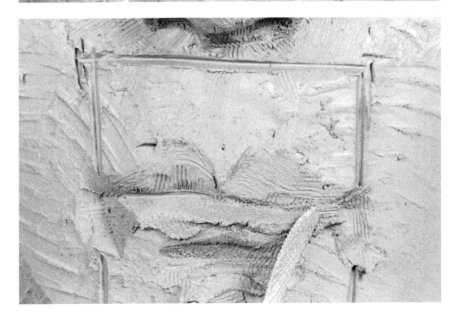

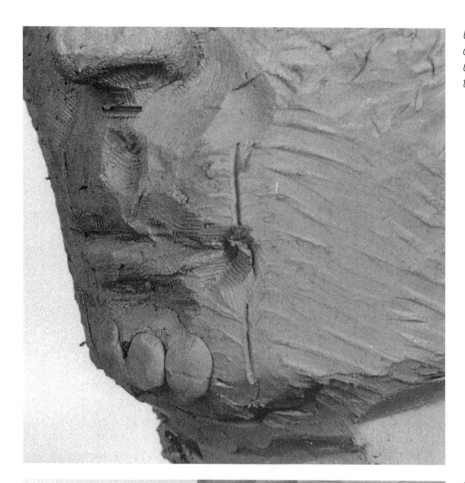

Use the riffler to make the groove of the philtrum centered above the upper lip. Add clay pellets to form the chin.

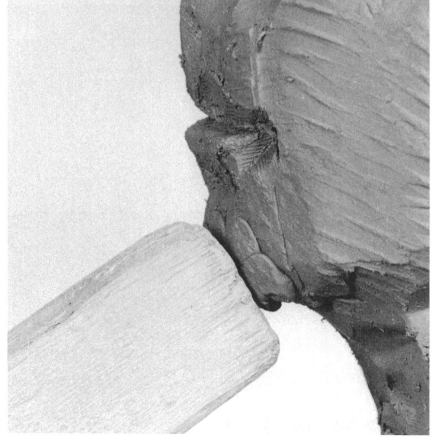

Tap the front plane of the chin on a 45-degree angle with the wood block.

Add small pellets of clay to the plane of the top lip to create volume.

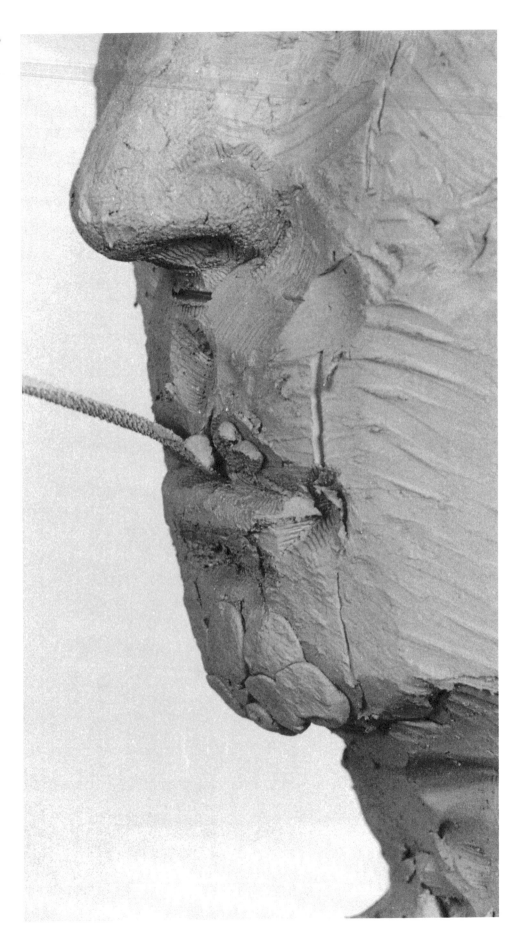

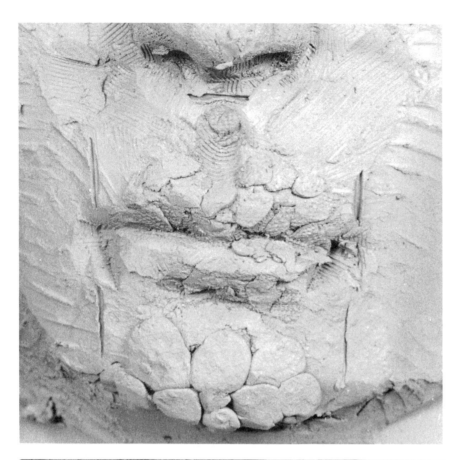

Establish the three forms of the upper lip—the round form in the center, and the ovals on either side.

Also build up the two forms of the lower lip—one oval form on each side of a flat center.

Delineate the form above the top lip, as well.

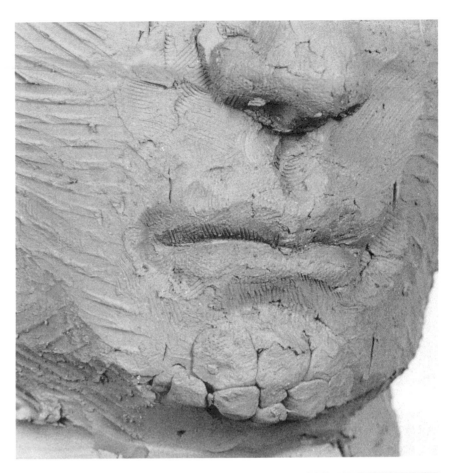

Place your riffler in between the seam of the lips; pull it from the center to the corner, emphasizing the contour and shape of the lips.

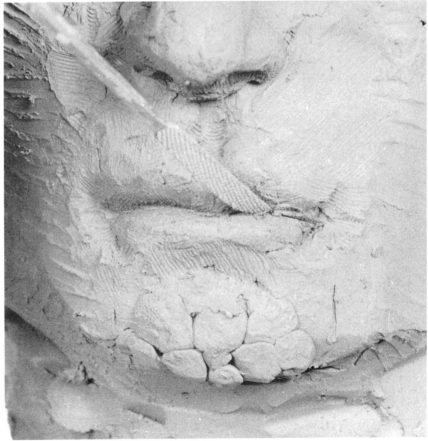

Twist the riffler in the corners of the mouth to open the dimples a bit.

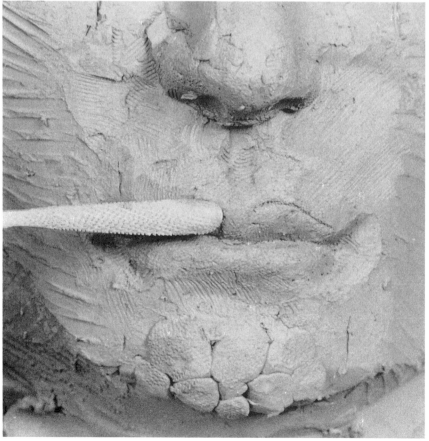

To delineate the thin ridge, called new skin, that goes around the lips, press the edge of the riffler along the outside contour of the lips.

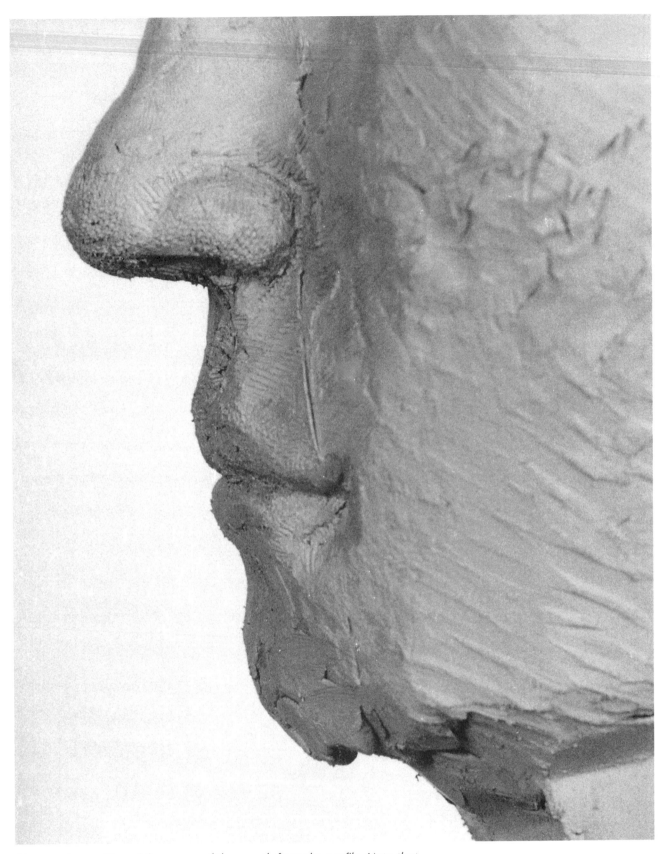

Observe the position of the corner of the mouth from the profile. Note that the mouth follows the contour of the jaw and ends further back on the side plane than the wing of the nose.

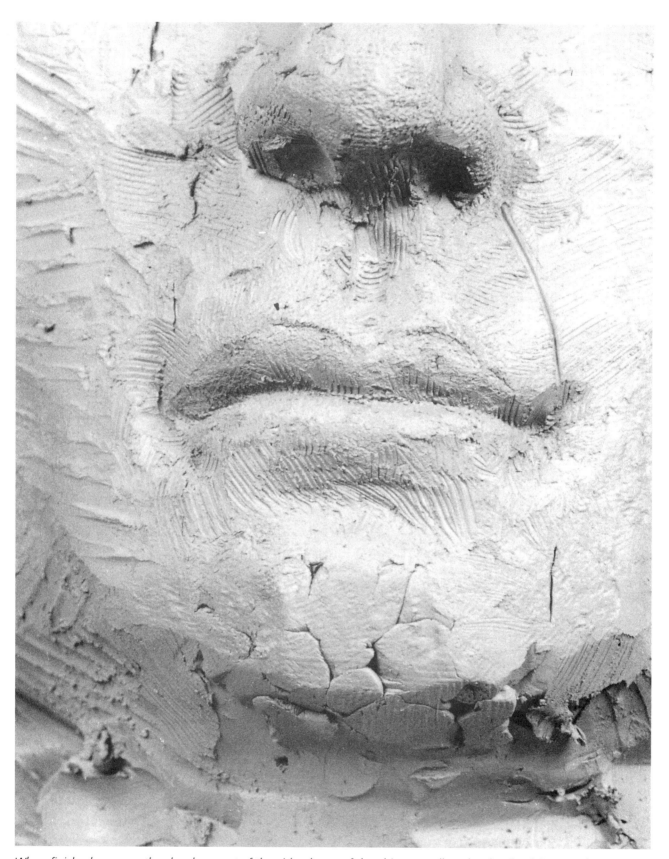

When finished, you see the development of the side planes of the chin, as well as the details of the mouth.

THE FINISHING PROCESS

To preserve your sculpture and make it a permanent, complete work of art involves a few simple finishing techniques: hollowing the piece, removing it from its armature, firing it, and adding a patina if you so desire. Fired clay is referred to as terra-cotta, or *baked earth*; it has a warm, brownish-orange color and is hard to the touch. You can leave your sculpture this natural fired hue, or you can apply a patina. Applying a patina is an easy and fun way to give the surface of an ordinary terra-cotta piece a unique and distinguished bronze-like appearance. The final finishing touch is to attach your portrait bust to a supporting base. There are many different materials you can use for this, from marble to wood and metal to Lucite. After mounting your sculpture, you will be able to exhibit it with pride.

HOLLOWING THE SCULPTURE

Your clay sculpture isn't a permanent piece until it's fired. I strongly recommend hollowing your piece before firing. You can fire it solid, but it takes longer to dry before and during firing, and weighs more. Also, solid pieces have a greater tendency to blow apart in the kiln during firing since there may be moisture trapped in air pockets in the clay. In the heat of firing, this moisture turns to steam and expands, resulting in ruptured or broken sculptures.

Hollow the piece before it dries out. The outside of the piece should be damp and firm enough to hold it's shape when emptied. For your clay to get to this point could take anywhere from one to five days with the piece unwrapped. It depends on two factors: the moisture content of the clay when you finish your sculpture, and the moisture levels in the room in which your piece is drying out. Since the length of this drying out stage can vary, check the firmness of your sculpture on a daily basis; use your best judgment as to when it's ready for hollowing. You should be able to tell.

To hollow your portrait, you'll need the cutting wire with handles for cutting and opening the sculpture, a wire loop for actually removing the necessary clay from inside the head, a wood modeling tool for scoring (this will be further explained), the C-clamp to secure your working surface, and an extra 14 x 14 x ³/₄-inch board (without an armature post) on which to rest the hollowed piece once you remove it from the armature. Note that this process can be a bit messy, so dress appropriately.

Once you fire the piece, you can apply a patina (color) to create a bronze look, or add a coat of clear butcher's wax to maintain and enhance the natural terra-cotta color. (See page 145.) Many sculptors, however, prefer to leave the piece as is after firing.

Position yourself behind the sculpture. Place your cutting wire on top of the head 2 inches behind the front plane. Holding the handles of the wire, pull down and back to the ears; stop about 2 inches above the ears. Continue by pulling the wire straight back toward you. Try to avoid catching the armature post with the wire. (The guideline in the photo should give you a rough idea of where the armature is within the head.) Don't remove the cut piece.

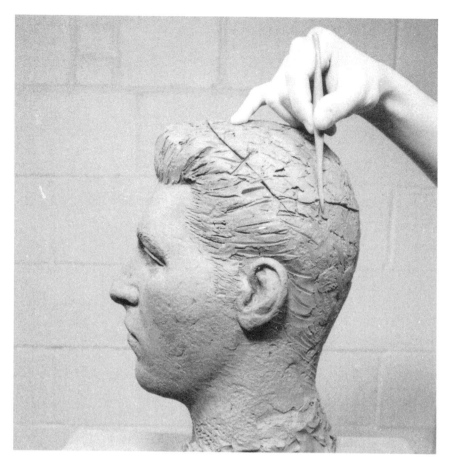

Before removing the top of the head, draw registration marks (lines) across the cut seam with a small wood tool; this implement is simply a smaller version of the wood modeling tool, which is available in many different sizes. You can certainly use the wood tool listed earlier in the tools section on page 45. These registration marks will help you align the top of the head to the bottom when you put the head back together after hollowing.

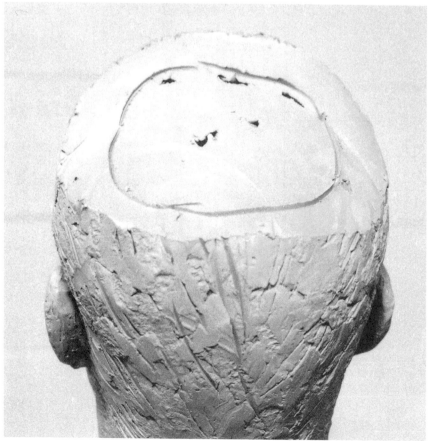

Remove the cut section of the top of the head and carefully place it aside. Draw a circle on the inside of the exposed head, leaving a 1½- to 2-inch border all around, between the circle and the outside of the sculpture.

Staying within the marked circle, scoop out the interior clay with the large wire loop tool. You can save the removed clay to use for another project; just spray it with water and wrap it well in plastic.

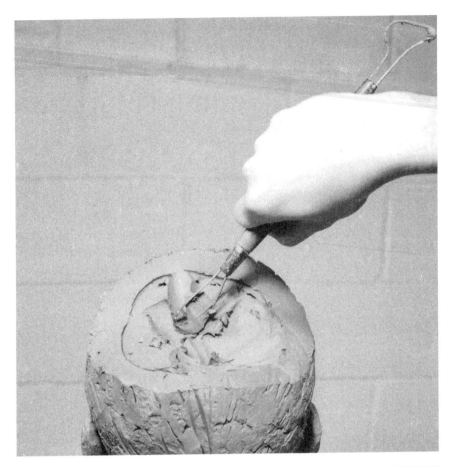

Hollow the head all the way down to the bottom of the piece. Once you clear away all the clay from around the armature post, remove the head from the post. To do this, use the C-clamp to clamp the armature board to the supporting pedestal. Placing your hands around the neck of the sculpture, gently twist and pull the head up off the board. If the head sticks to the board and is difficult to remove, cut under the very bottom of the piece with the cutting wire to free the neck from the board.

Place the sculpture on another work board—one without an armature post—and finish hollowing the head. You won't need the armature anymore. Keep the neck thicker than the rest of the sculpture, because it supports the head, and to avoid digging right through the face, keep the face area a little thicker as well. No area needs to be less then 1½ to 2 inches thick.

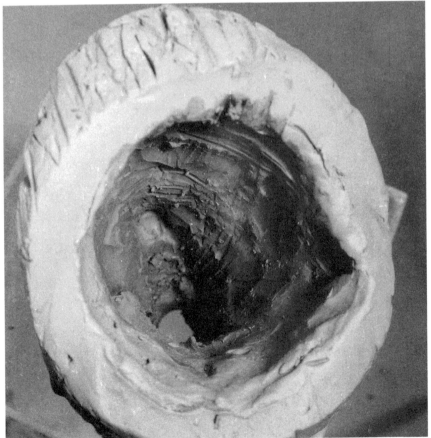

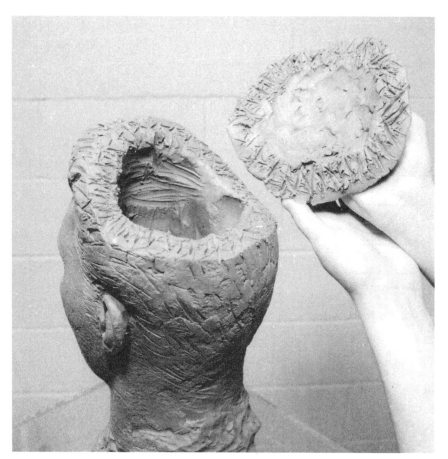

Using the wire loop modeling tool, hollow the removed top portion of the head, also leaving a 1½- to 2-inch border of clay around the edge. Score the borders of both pieces with deep crisscrossing lines. Saturate the borders of both pieces with water. Locate the registration marks you made earlier, line them up from piece to piece, and replace the top. Press and wiggle the top piece on to the bottom section. Water and clay will ooze out a bit from the seam—don't worry, this is what you want.

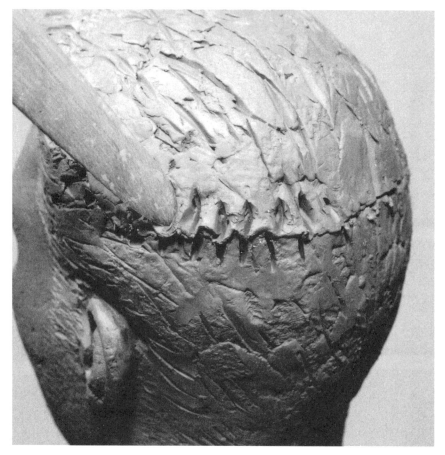

Using the wood modeling tool only, pinch the seam together, pressing from the top section down into the bottom one. Continue to pinch the seam all around the head with the wood tool. Then, repeat the pinching all around, going from the bottom section up into the top.

Remodel the hair over the seam area with fresh clay, or with clay that you removed from the head during the hollowing process. Duplicate the original hair texture using the rake tool and wood block. Touch up any minor mishaps, and sign and date your sculpture on the side or back of the neck. Leave the piece unwrapped to air dry for approximately two weeks before firing it.

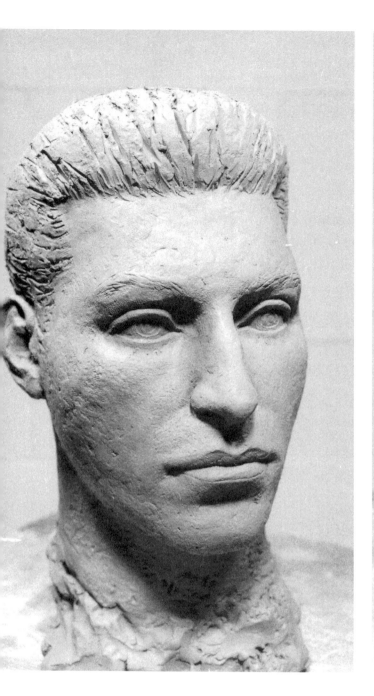
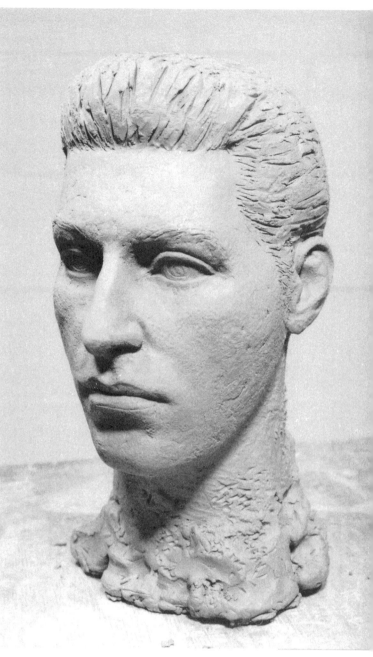

This is the finished, dried piece from two angles. The clay doesn't dry uniformly; thinner sections—for example, the nose and ears—dry first. While drying, the clay becomes lighter in color and weight; once dry, it is harder in texture. In this state, it can break more easily, and the surface becomes dull and more chalky. Basically, it loses its pizzazz.

FIRING

Most likely, you'll have someone other than yourself do the firing of your piece. You can find kilns at schools that offer ceramic classes; also check the resource listing on page 158. Kilns have three temperature settings: low, medium, and high. To completely dry out my piece, I had it fired on low for 10 hours, before bringing up the heat to medium for another 6 hours. I did this because pieces explode in kilns when moisture, trapped in air pockets in the clay, turns to steam. If there's no moisture, there's no problem and no chance of explosion.

After firing my piece for six hours on medium, I continued firing it for six more hours on high. This works for me using cone 08 (1600 degrees). A cone is a small temperature indicator that is placed in the kiln during firing; when the kiln reaches cone temperature, the cone melts and the kiln shuts off. Other cones and settings besides cone 08 will work; use clay that fires at temperatures between cone 02 and 08. Check with the person firing your piece for the correct temperature. Clay holds the heat for many hours after firing, so let your piece cool down before handling it.

The clay will shrink a small percentage and tighten during firing, so the details and texture of your sculpture may appear sharper after firing. Red clays fire to anywhere from an orange to a light terra-cotta color, while gray clays usually fire to white. Fired clay is brick hard and can even be kept outside in warm weather. However, I don't recommend leaving terra-cotta sculptures outdoors in freezing conditions as any ice will eventually crack the clay.

Place the sculpture upright or on its side in the kiln.

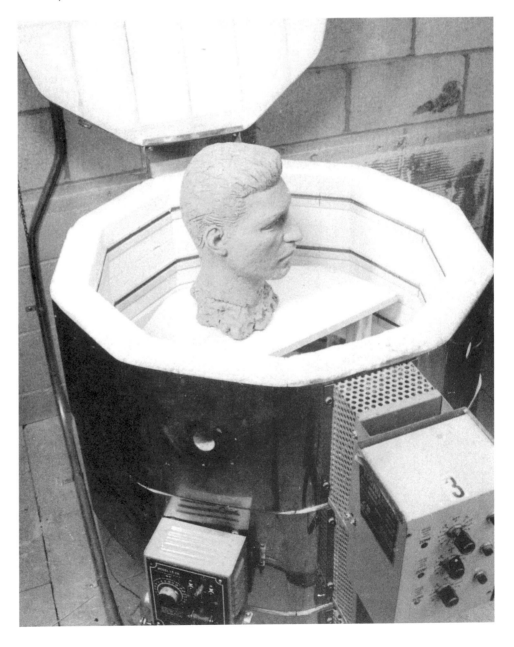

PATINAS AND MOUNTING

The finished fired piece has its own charm in its natural terra-cotta color. However, adding a patina, or surface coloring, can bring out the depth and highlight the surface texture of your work, as well as affect the mood of your sculpture. Think of a patina as a transparent layering of colors over the sculpture's surface. I really enjoy experimenting with different patina colorings. There are no mistakes; you can redo a patina as often as you like.

An actual patina is the green oxidized color of weathered bronze. Often artists apply acids to torched bronze to mimic the natural oxidized look. Different acids create different colors, and the variety and combinations of possible colors are virtually endless. Patinas can be vivid and bright or somber and subtle. It's purely a matter of personal taste. Your only limitation is your imagination.

In this section, I'm going to create a basic green bronze patina. To do this, you need the following materials and tools: hydrocal (a white gypsum cement powder available in art supply stores), acrylic paints, water, paintbrushes (including a small one for the hydrocal), paint mixing bowls or pans, shoe polish, newspaper, a blow drier, and a couple of soft cotton cloths. Here I'll be using acrylic paints in gold, burnt umber, white, and green (you can use any green that you like); you can find these at your local art supply store. I like Winsor & Newton acrylics, especially their gold, and I prefer acrylics (to oils, for example) because they dry quickly, mix together well, only require water as a medium, and clean up easily. For paintbrushes, you'll need a soft-bristled, wide brush and a round brush. You should have shoe polish in both black and brown.

The finished, fired portrait prior to any patina application.

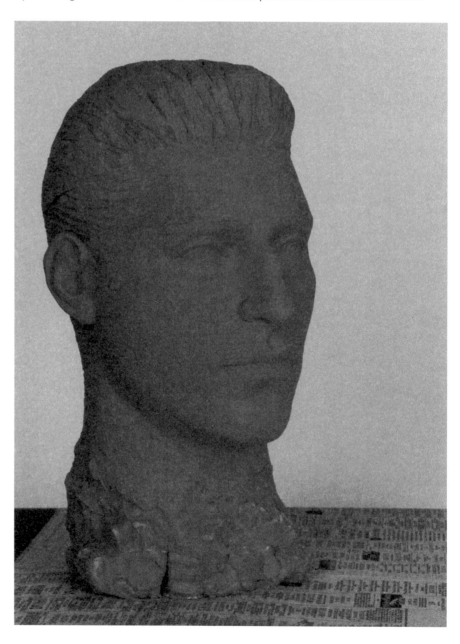

To begin, inspect your fired sculpture for small cracks. If there are any, repair them with a watery mixture of hydrocal. To prepare the hydrocal, pour 2 to 3oz. of water into a small disposable cup and, using a plastic spoon, sprinkle in the hydrocal until it comes up to the water level. Mix this until it becomes a thin, creamy solution. Working over a piece of newspaper to catch any drips, dip the small brush into the mixture and let the solution drip from the brush into the cracks. Do this until you fill all the cracks. Scrape or clean off any excess hydrocal from the sculpture with a damp cloth before it sets, and if necessary, you can sand off any hardened hydrocal bumps the next day.

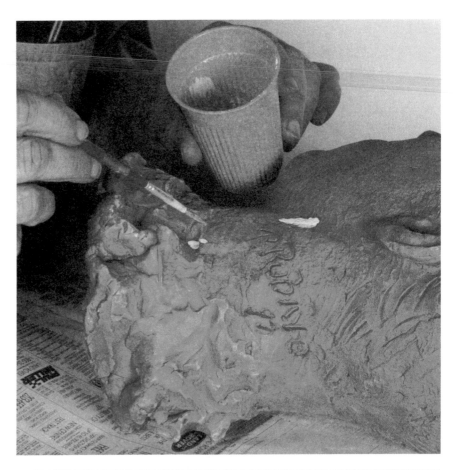

With the round brush, paint the entire piece gold. Use the paint straight from the tube with only a little water to help spread it into any crevices. Apply two coats. Make sure the piece is well coated and thoroughly dry before moving on to the next step.

Squeeze some burnt umber paint into a mixing pan, and add a drop of water.

Coat the entire piece with the burnt umber, using a clean round brush.

Use a stippling motion (applying the paint with repeated small dabs) to spread the color evenly, while blow drying the painted surface. The stippling eliminates streaking, and doing this while blow drying helps prevent excess paint from dripping and also speeds up the drying time.

*Occasionally dab the brush on the
newspaper to remove excess paint.*

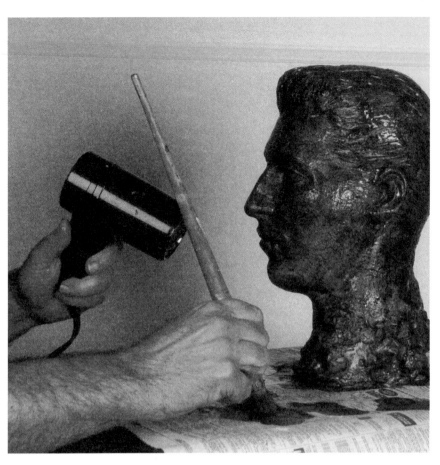

*Continue drying and stippling. Blot
the surface with the brush to remove
any excess clumps of paint. The gold
undercoat should show through the
burnt umber. Let the paint dry
before applying the next color.*

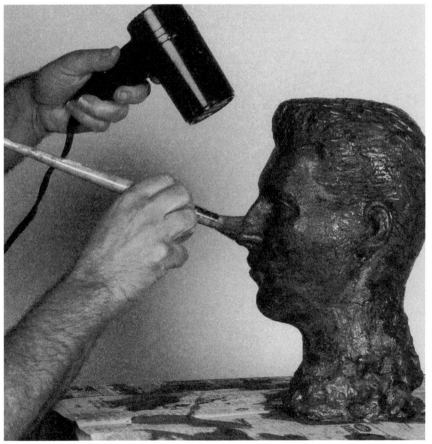

Squeeze a round bead of green paint about a quarter of an inch in diameter into a clean mixing pan.

Add a bead of white paint about 1 inch in diameter next to the green one.

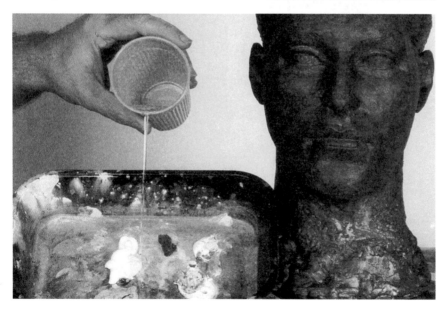

Add enough water (maybe 1 or 2oz.) to create a watery light green color.

Soak a clean round brush in the paint mixture and spread it liberally on top of the sculpture. Let the paint drip all over.

Cover the entire sculpture with the green paint mixture.

Stipple and blot the sculpture with your brush to blend and dry the paint, while also using the blow drier.

After you cover the piece completely with the green paint mixture, inspect it carefully. Notice the undercoats showing through the green. If you want, you can make the finish lighter or darker at this time. Once you're relatively happy with the coloring, blow dry the piece thoroughly.

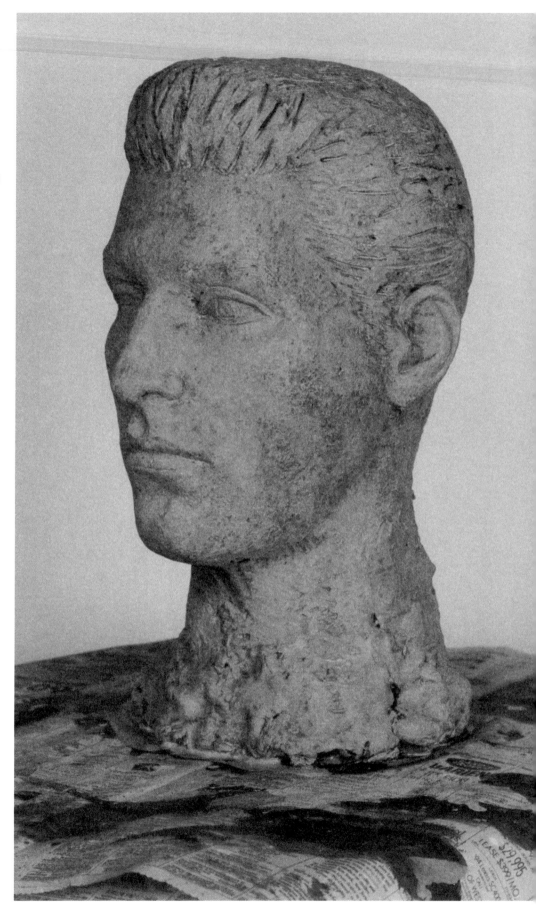

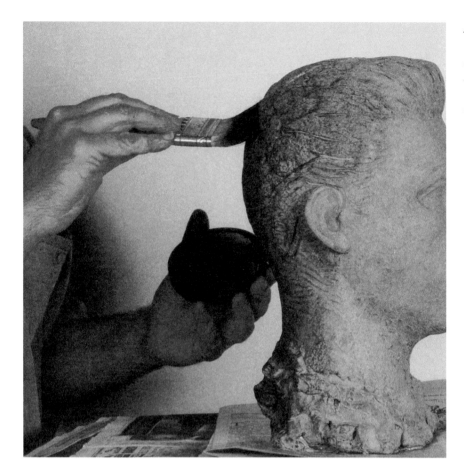

Apply black shoe polish sparingly to the piece with a soft, wide brush. Spread the polish across the top surface of the sculpture lightly, using a feathering motion. Allow a lot of the green paint to show through the polish.

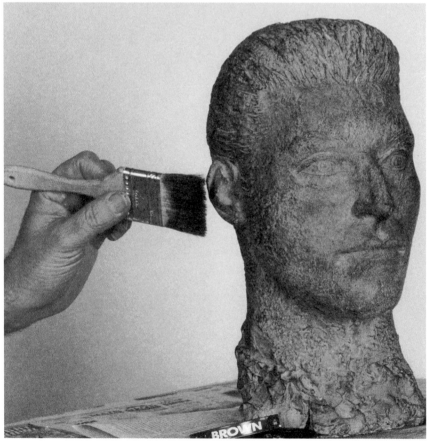

Using a clean brush, apply a light coat of brown shoe polish over the black polish. Use the same feathering technique.

Pre-buff the piece by feathering the surface with a clean dry soft brush.

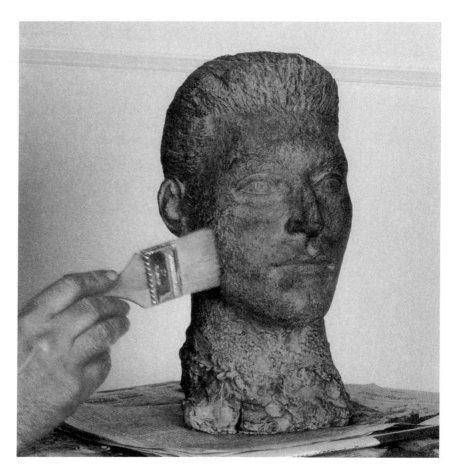

Buff the entire piece with a soft cotton cloth. You can also just buff highlights onto a few areas if you prefer a matte finish overall. This is a basic green bronze-style patina, but keep in mind that you can also create your own patinas using the colors of your choice.

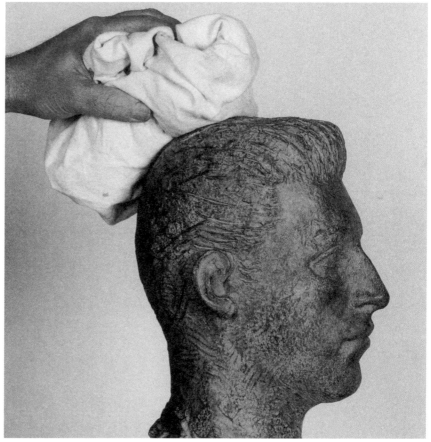

MOUNTING

Bases for mounting sculptures come in a variety of materials, colors, shapes, and sizes. There is marble, stone, exotic and laminated wood, Lucite, bronze, and stainless steel, just to name a few. Shapes can vary from rectangular or square to cylindrical or free-form. The size of the base depends on the size of the sculpture—it should be large enough to support the piece—and the color could be the natural color of the base material itself. Since the base becomes part of the overall design of your sculpture, the choice of material, shape, and size is one of aesthetics.

Most sculpture suppliers or mold makers and casters will custom cut a base and mount your sculpture to it. To do it yourself, for a life-size portrait with both head and neck, you could have a piece of oak cut to 7 1/2 x 7 1/2 x 3 inches at a lumber yard, and then sand it and rub it with linseed oil. Using Devcon 5 Minute Epoxy with Hardener, glue the sculpture to the base. Whenever handling epoxy always read the instructions thoroughly, and don't use too much—you don't want the epoxy to ooze out from under your sculpture onto the surface of the base.

Mix some of the epoxy and apply it to the bottom of the piece. Affix the sculpture to the base of your choice.

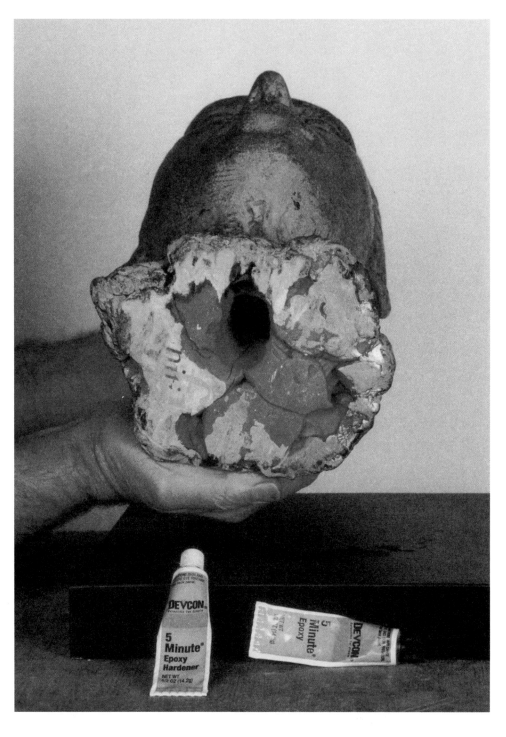

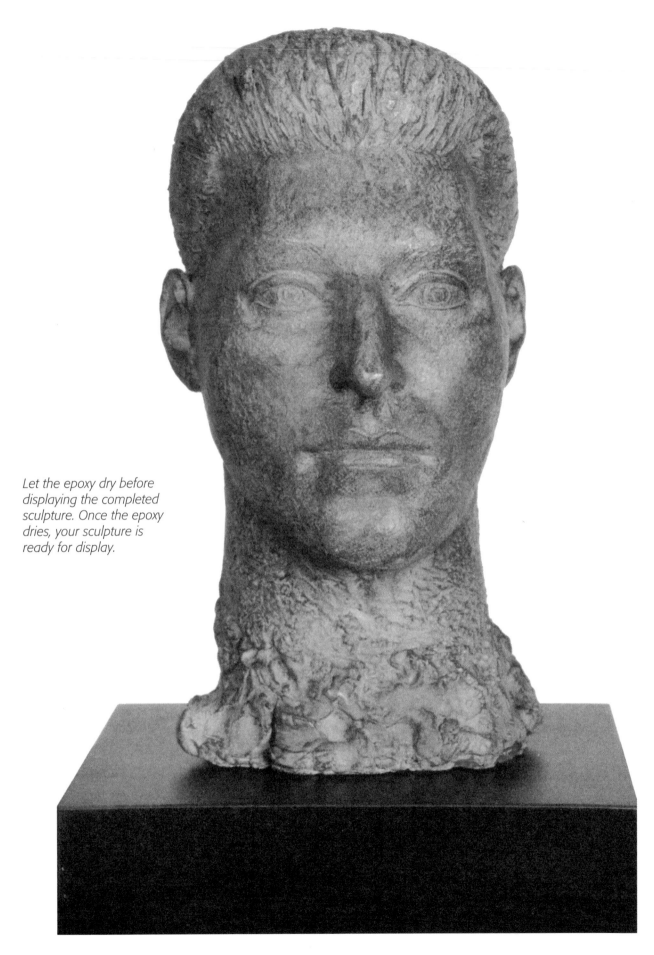

Let the epoxy dry before displaying the completed sculpture. Once the epoxy dries, your sculpture is ready for display.

RESOURCES

These first four suppliers are the ones I use almost exclusively. They provide consistently reliable, quality service, and I highly recommend them. The remaining listings are additional sculpture resources that may be useful. Also try looking in your local yellow pages under "Sculptors," "Sculptors' Equipment and Supplies," or "Pottery" for more options.

Ceramic Supply, Inc.
7 Route 46 West
Lodi, NJ 07644-1399
(201) 340-0089
Clay suppliers, but you have to buy in bulk, which means about 500lb. per order; this is good for sculpture groups.

The Clay Place
60 East Avenue
Norwalk, CT 06851
(203) 874-6464
Provides clay firing, especially of pottery. They fired the portrait sculpted for this book.

Peters Sculpture Supply
415 East 12th Street
New York, NY 10009
(212) 777-1079
Carries sculpture tools and equipment, but not clay. You can call for a catalogue, and shipping is available. The store also custom makes tools and is the distributor of the Rubino 3-in-1 Armature (see page 44). Also carried: the video Life-Form Emerging: Maquette to Monument *by Peter Rubino.*

Ranieri Sculpture Casting
55 Prince Street
New York, NY 10012
(212) 982-5150
Provides custom casting in all mediums—plaster, wax, bronze, bonded bronze, Marplex—and will apply patinas. Sells custom bases, mounts sculptures, and does restoration, too. Also does enlargements, translating small sculptures into monument-sized works.

Sculpture Supplies

Dick Blick Art Materials
P.O. Box 1267
Galesburg, IL 61402-1267
To order: (800) 447-8192
For product information: (800) 933-2542
This mail order catalogue sells acrylic paints, paintbrushes, sculpture tools, 25lb. and 50lb. blocks of a number of different clays, and even kilns! Call for a free catalogue.

Pearl Art and Craft Center
308 Canal Street
New York, NY 10013
(800) 221-6845
This large art supply store sells clay (in 50lb. blocks and smaller) and sculpture tools, as well as acrylic paints and paintbrushes. You can call for a catalogue.

Sculpture House Casting
155 West 26th Street
New York, NY 10001
(212) 645-9430
Stocks a variety of sculpture supplies.

Bronze Casting Foundries

Argos
Route 312
Brewster, NY 10509
(914) 278-2454

Art De Luxe Co., Inc.
43–10 23rd Street
Long Island City, NY 11101
(718) 784-2481
Production sculpture casting (this is mass casting—for example, they will cast the same sculpture 100 times).

Bedi-Makky
227 India Street
Brooklyn, NY 11222
(718) 383-4191

Cavalier Renaissance Foundry
250 Smith Street
Bridgeport, CT
(203) 384-6363

Joel Meisner Foundry and Gallery
115 Schmitt Boulevard
Farmingdale, NY 11735
(516) 249-0680

Loveland Academy Foundry
205 12th Street, SW
Loveland, CO 80537
(800) 726-5232

Shidoni Foundry and Gallery
P.O. Box 250
Tesuque, NM 87574
(505) 988-8001
Located five miles north of Santa Fe.

Workshops

The following schools all offer sculpture classes. I'm a regular instructor at the National Academy School of Fine Arts in New York and have a class at The Clay Place in Connecticut. I also teach one to two workshops a year at the Loveland Academy in Colorado and the Scottsdale Artist's School in Arizona. The classes are all listed in the schools' catalogues.

The Clay Place
60 East Avenue
Norwalk, CT 06851
(203) 847-6464

Loveland Academy of Fine Arts
205 12th Street, SW
Loveland, CO 80537
(800) 726-5232
The academy sells sculpture tools as well.

National Academy School of Fine Arts
5 East 89th Street
New York, NY 10128
(212) 996-1908

Scottsdale Artist's School
3720 North Marshall Way
Scottsdale, AZ 85252-8527
(800) 333-5707

INDEX